The Campus History Series

UNIVERSITY OF
NORTHERN COLORADO

On the Cover: During the 1920s, education students were required to take a wide variety of courses such as literature, songs and games for kindergarten and primary children, rural school problems, and schoolhouse construction. The course called primary grade methods even included specific instruction on the proper practice of writing and illustrating on the blackboard. This group of students practices their writing techniques under the watchful supervision of their instructor. (Photograph courtesy of the UNC University Libraries Archival Services Department.)

The Campus History Series

UNIVERSITY OF NORTHERN COLORADO

MARK ANDERSON AND JAY TRASK

ARCADIA
PUBLISHING

Published by Arcadia Publishing
Charleston SC, Chicago IL, Portsmouth NH, San Francisco CA

Printed in the United States of America

Library of Congress Catalog Card Number: 2009943324

For all general information contact Arcadia Publishing at:
Telephone 843-853-2070
Fax 843-853-0044
E-mail sales@arcadiapublishing.com
For customer service and orders:
Toll-Free 1-888-313-2665

Visit us on the Internet at www.arcadiapublishing.com

Mark Anderson would like to dedicate this work to his bright and beautiful children, Brian and Emily.

Jay Trask would like to dedicate this work to his wife and best friend, Ruth.

CONTENTS

Acknowledgments 6

Introduction 7

1. Colorado State Normal School 11

2. State Teachers College of Colorado 43

3. Colorado State College of Education 61

4. Colorado State College 89

5. The University of Northern Colorado 111

ACKNOWLEDGMENTS

The authors are grateful for the support of many people without whose interest and assistance this project would not have been possible. Dr. Gary Pitkin, dean of the university libraries, associate dean Helen Reed and head of library administrative services Joan Lamborn were enthusiastic and encouraging. Shirley Soenksen, Eve Measner, and Kay Lowell of the university archives provided valuable assistance and expertise. Thanks also to the rest of the university libraries faculty and staff who covered for us in our absences as we gathered images and researched their significance.

The primary sources of information that informed the captions are the following:

> Albert Carter. *Forty Years of the Colorado State Teachers College Formerly the State Normal School of Colorado 1890–1930.* Colorado State Teachers College. 1930.
> Robert Larson. Shaping Educational Change: the First Century of the University of Northern Colorado at Greeley. Colorado Associated University Press. 1989.
> William R. Ross. The Four Seasons of William R. Ross. 1980. Unpublished manuscript in the University Archives.
> Robert C. Dickerson. *The University of Northern Colorado. A Legacy of Promise.* Newcomen Society of the United States 1989.
> The *Mirror*, the *Cache la Poudre*, the *Colorado State Normal School and the Colorado State Teachers College Bulletins* and the *Crucible*.

Most frustrating was that space considerations prevented us from recognizing the contributions of all students, faculty, and administrators who have significantly shaped the educational environment of the University of Northern Colorado in its first hundred years. We are especially sorry that we were unable to provide space or images to celebrate the accomplishments of certain nationally recognized scholars whose research has enhanced our academic reputation, such as Paul McKee, Earl Rugg, and Ethan Allen Cross. Although we tried to maximize the number of images of students in their academic and social activities, space requirement prevented mention of all the varied and fascinating academic, athletic, and social organizations that have contributed to our students' educational experience. Another source of frustration was the fact that certain images in our collection, which would have been valuable additions, could not be formatted appropriately for this project.
 All images are courtesy of the UNC University Libraries Archival Services Department.

INTRODUCTION

It was almost inevitable that the small western farming community that evolved from Nathan Meeker's original Union Colony would one day host one of the country's premier teacher training colleges. Attracting an institution of higher learning had been part of Meeker's design. The Union Colonists who had settled at the confluence of the Platte and Cache la Poudre Rivers in 1870 were better educated than average frontier town residents. Greeley's businessmen understood that quality schools under the guidance of well-trained teachers constituted a fundamentally refining influence that would distinguish Greeley from Colorado's rough mining towns and military camps, would attract new settlers, and most important, new commerce.

Greeley's first two attempts to sponsor higher education in the community had failed. In 1874, Meeker, while editor of the *Greeley Tribune* had initiated an unsuccessful campaign to persuade Greeley businesses to raise sufficient money to wrestle the Colorado State University from Boulder. In the same year, Greeley citizens had bid for the right to host the land grant college to be established under the Morrill Land Grant Act of 1862 but lost out in that attempt to Larimer County.

Greeley's turn finally came in 1889, ten years after Meeker's death, when Greeley's Sen. James McCreery steered a bill through the state legislature that would establish the state normal school at Greeley and contribute $10,000 of state funds toward the construction of a suitable building, provided the citizens of Greeley would donate the necessary land and $15,000. Greeley did its part, and when the state legislature reneged on its share of the building fund, the citizens of Greeley took up another collection and came up with the additional $10,000 as well.

In 1890, normal schools did not carry the same academic prestige that a state university or an agricultural college did. Nevertheless preparing elementary school teachers for public schools was an essential process in a democratic society. Ultimately one might argue that for politically progressive but religiously conservative Greeley, a teachers college was a more natural fit.

In its first hundred years, University of Northern Colorado has been extremely fortunate in the administrative skill, energy, and vision of its early presidents. Dr. Z. X. Snyder, our second president, was one such visionary. His ideas shaped everything that the school was to become. President Snyder was a trained biologist, and for him, the principles of science were always relevant. A disciple of John Dewey, President Snyder advanced the idea of "child-centered education," instruction that nurtured a student not only intellectually but morally and physically as well. President Snyder believed in hands on education with plenty of time for out-of-classroom nature excursions, laboratories, field trips, and other opportunities to put memorized principles and concepts to practical application. The system was based on the German model for teacher education. In 1890, Germany was the not only the source of innovations in science and technology but of teacher training as well. Dr. Snyder admired the

German system in which higher education was widely available regardless of an applicant's wealth or social status. German education was government financed and free of religious sectarian bias.

Dr. Snyder's other major influence was John Dewey, the famous American philosopher and psychologist, whose ideas inspired a number of movements in the fields of social and educational reform. Prior to Dewey and his disciples, the standard classroom scenario consisted of a teacher delivering lectures to students who listened attentively, supplemented by readings from a text. Students demonstrated what they had been able to memorize by reciting lessons and taking tests.

Dewey and the other progressives knew that an intellectual grasp of facts and concepts was not enough. Lessons were soon forgotten unless the curriculum included generous amounts of hands-on learning activities. The laws of science and nature needed to be supplemented by laboratory experiments and field trips. In the arts, creativity was encouraged, because abstract aesthetic concepts are meaningless unless a child has the opportunity to apply them in a variety of media.

Dewey and his disciples believed that effective education is holistic in its scope and that no student activity was outside the teacher's sphere of influence. Sports and physical play were encouraged, not only because they contributed to a healthy constitution but also because these activities developed moral character by giving the child the opportunity to apply the rules of sportsmanship and fair play.

The normal school that evolved from Dr. Snyder's vision was committed to graduating professional teachers who were skilled in the techniques of progressive education and who would effectively prepare their students for the roles they would eventually assume as participants in a modern industrial economy and a democratic society.

One of Snyder's first appointments as principal of the training school was Dr. John Arnold Kleinsorge, who had received his doctorate from the University of Jena. His choice to organize Colorado's first kindergarten was Laura Tefft, who had studied at the famous Froebel-Pestalozzi Kindergarten School in Berlin.

Under Dr. Snyder's administration, the school evolved from a two year, certificate-granting institution into a four-year program that awarded a bachelor of pedagogy degree. The first master's degrees in education were awarded during the Snyder administration. Some of Dr. Snyder's other experiments included student governance, ungraded adult education, specialized training for kindergarten teachers, and a summer school program that brought nationally recognized scholars such as Davis Starr Jordan of Stanford to the Greeley campus.

President Snyder's successor, John Grant Crabbe, is remembered for his promotion of the liberal arts. A gifted musician himself, he developed the music program from a collection of choruses and glee clubs to one in which instrumental music was taught and performed. Like Greeley itself, Crabbe was religiously conservative but politically progressive. He strongly endorsed religious activities on campus and believed that religious activity, as part of the overall college experience, should prepare students for participation in a free and democratic society. Thus President Crabbe was an ardent proponent of student participation in college administration, especially on issues such as curriculum and student fees.

President Crabbe found it troubling that so many gifted teachers, after undergoing the rigorous training program, left after a year or two to pursue more lucrative and less stressful careers in other fields. As president of the American Association of Teachers Colleges, he worked to enhance the professional status and salaries of career teachers.

Perhaps President Crabbe's least recognized accomplishment was his response to the 1918 Spanish Flu epidemic, which killed 500,000 people around the country. While many colleges were closing down for the duration, President Crabbe developed a quarantine plan that kept this school open. Student health was monitored. Social gatherings were not allowed. Students were actually forbidden from leaving campus. Their days were spent in the classroom and in their rooms. The plan apparently worked, and no CTC students died during the epidemic.

President Crabbe died suddenly of a heart attack in 1924 and was replaced by the youthful and charismatic George Frasier. Dr. Frasier, whose doctorate was from Columbia, was also a disciple of John Dewey and progressive education. Boundlessly energetic, Dr. Frasier's administrative accomplishments were impressive. He increased entrance and graduation requirements for students. Under Frasier, faculty research doubled and the number of doctorates among CTC faculty increased dramatically. Frasier's own scholarly accomplishments were equally impressive. While president, he authored or co-authored three books and numerous articles in the fields of education and education psychology. The Frasier administration saw the construction of 14 new buildings, including Gunter Hall and Cranford Field.

Frasier developed the doctoral program in education and education psychology. His plan for the education doctorate, as an alternative to the doctorate, reflected John Dewey's pragmatic philosophy. Instead of requiring a theoretical doctoral dissertation for graduation, a candidate conducted three field studies.

Frasier's successor, Pres. William R. Ross (1948–1964) is best known for his aggressive expansion of college buildings and grounds. His engineering background made him an ideal candidate to deal with the increasing space requirements of a postwar student body. While vice president for buildings and grounds, Dr. Ross had devised a plan for rapidly expanding temporary housing for returning World War II veterans who were attending college under the GI bill. His presidency saw the construction of Frasier Hall to house the music and performing arts programs and faculty apartments.

But his most visionary accomplishment and one that was somewhat controversial at the time was the acquisition of the 170-acre Petrikin farm, adjacent to campus, where the University Center and the west campus would eventually be built.

Pres. Darrel Holmes (1964–1971) developed the campus that Ross had purchased. During his tenure, one third of buildings on the new west campus were completed and several others were in the planning stages. Also during President Holmes's administration, the college was granted university status and was renamed the University of Northern Colorado.

Pres. Richard R. Bond (1971–1981) was committed to participatory democracy. His administration enlarged the role of student representative council and the faculty senate in the governance process. He also established student exchange program that enhanced the international footprint of the institution.

Robert C. Dickeson (1981–1991) was faced with a crisis of declining enrollment. His response was to developing a comprehensive and controversial program analysis plan that emphasized centers of excellence. UNC needed to cease trying to be all things to all students and concentrate resources in the areas in which it could excel. During the Dickeson administration, the industrial arts and home economics departments were eliminated and the educational technology department was created. Dr. Dickeson presided over the 100th anniversary celebration that saw the establishment of Cranford Park on the site where Cranford Hall had stood.

The images in this collection were selected to illustrate how the decisions made by UNC's first eight administrations in response to the changing educational needs of an increasingly post-industrial, computerized society, transformed a elementary school teachers training school in a dusty frontier town into a university offering more varied educational opportunities that attracts scholars from all over the world. These images show the gradual evolution of the campus in terms of the space it occupied and its relationship with the residential and business districts that grew out from Greeley to envelop it. Most importantly these images portray the changes as they occurred in the succeeding generations of UNC students: their clothing styles, their social activities, and their relationships with one another, with school faculty, and with the larger Greeley community.

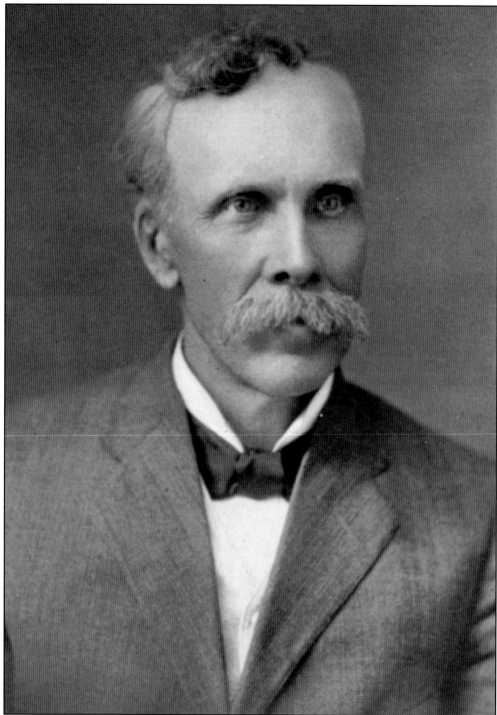

A. B. Copeland, the superintendent of the Greeley School District in 1889, found himself forced to search in Nebraska and Kansas for qualified teachers. He therefore proposed the establishment of a school to train teachers. It would become the Colorado State Normal School and would be located in the northern Colorado town of Greeley.

One

COLORADO STATE
NORMAL SCHOOL

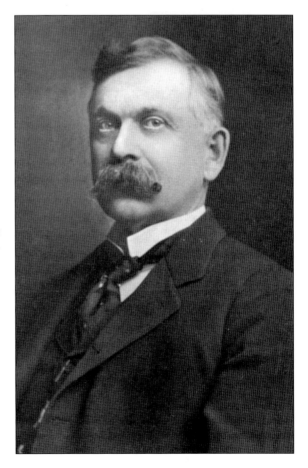

State senator James McCreery
sponsored Colorado Senate Bill 104
in the 1889 state legislature, which
said, in part, "A State Normal School
is hereby established at or near the
city of Greeley . . . the purpose of
which shall be the instruction in the
science and art of teaching, with the
aid of a suitable practice department
. . . PROVIDED, that a donation shall
be made of a site . . . consisting of
forty acres of land." The McCreery
bill excited a considerable amount
of controversy. Opponents argued
that the Normal Department at the
University of Colorado at Boulder
was sufficient to fill the growing
state demand for qualified teachers.
However, after overcoming a
senate filibuster and a negative
house committee report, Colorado
Senate Bill 104 was finally passed
and signed into law by Gov. Job A.
Cooper on April 1, 1889.

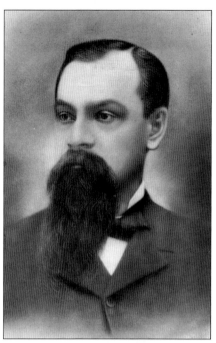

Thomas Gray was recruited by the first board of trustees to serve as the first principal of the state normal school. The title "president" was not considered appropriate because a normal school education did not have the same academic status as a college education. A native of Wisconsin, Dr. Gray was well qualified for this position, having been president of the St. Cloud, Minnesota, Normal School and state director of the National Education Association of Minnesota.

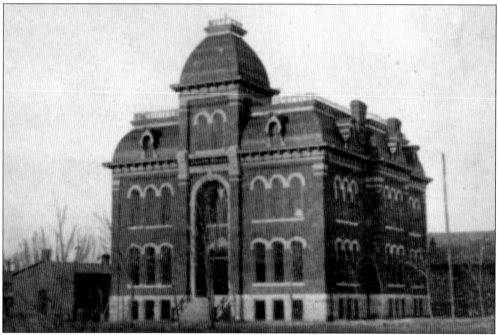

The first day of classes was October 6, 1890. The proposed Normal Building being under construction, administrative offices were housed in the Weld County Courthouse (pictured above). Classes were held in the Opera House, in the various downtown churches, and in a storeroom above a paint store on Ninth Street between Seventh and Eighth Avenues. Classes were taught by principal Gray assisted by a four-member faculty: Paul Hanus (pedagogy), Margaret Morris (history), Mary Reid (mathematics and geography), and John R. Whitman (music).

A commencement ceremony for the 12-member class of 1891 was held on June 3, 1891. Two days later, principal Gray's resignation was announced by the Greeley Tribune.

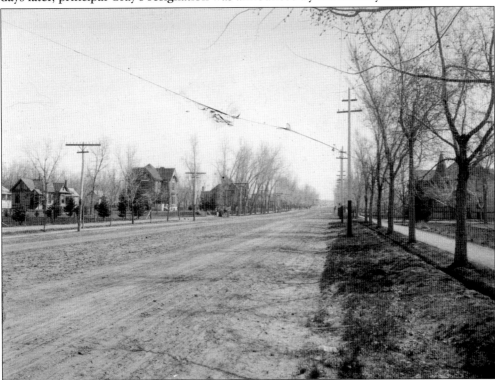

John P. Cranford, a New York banker and friend of Greeley's founder, contributed 21 of the 40 acres required for the school buildings and grounds. Mr. Cranford's donation, on a hill a mile south of Greeley, which was known to the locals at the time as Rattlesnake Hill, was immediately renamed Normal Hill. This picture shows Normal Avenue from downtown Greeley south up to Normal Hill very much like it would have looked to Greeley residents in 1891.

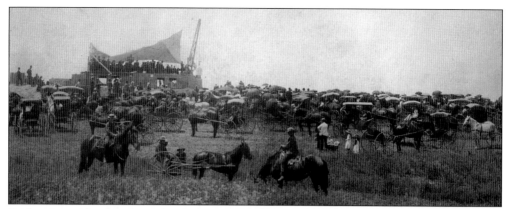

Friday, June 13, 1891, was the date set for the cornerstone laying ceremony for the new normal school building. Morning trains brought over 600 distinguished guests to attend the ceremony, including Gov. Job A. Cooper and Lt. Gov. William G. Smith. The party paraded from downtown Greeley, up Normal Avenue, to the school grounds. The cornerstone itself had been donated by J. M. Wallace, president of the First National Bank of Greeley and also president of the board of trustees.

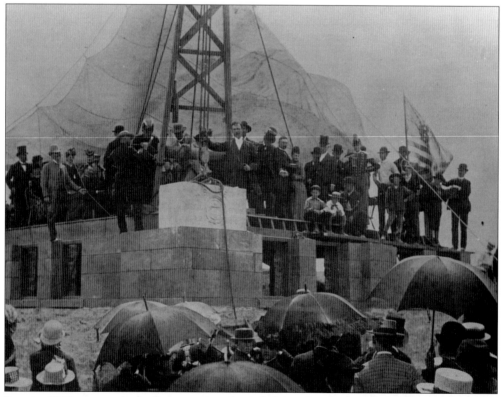

Senator McCreery made the first speech, acknowledging that the successful teacher must have a "scientific knowledge and expert skill in the management of his little community . . . these branches of inquiry are essentially professional and . . . can only be generally acquired in the professional school for teachers." Governor Cooper concurred. "When we compare the school ma'am of our boyhood," he orated, "with the wide awake, practical, keen sighted and thoroughly trained teacher of today we see what normal institutions are doing."

With principal Gray's abrupt departure, the board of trustees was forced to search for his replacement. Zachariah Xenophon Snyder was appointed president on August 12, 1891. Dr. Snyder previously served as president of the Indiana State Normal School in Indiana, Pennsylvania, the best-known normal school in the nation at the time. He had been informed of the vacancy by his old friend, Senator McCreery, an Indiana State Normal School alumnus.

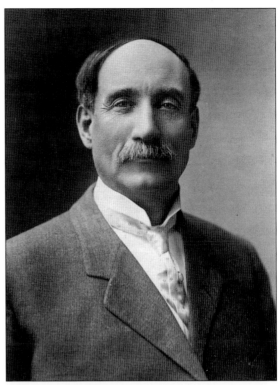

Dr. Snyder, pictured here in his office late in his career, was an early advocate of progressive education and was a disciple of John Dewey.

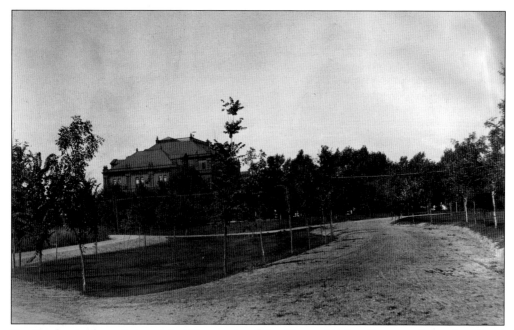

Dr. Snyder took an interest in all aspects of the Normal School's operations. A trained biologist, he was especially interested in landscaping. One of his first acts as president was to order planting of over 400 trees and a large number of bushes and shrubs. In this picture and the two following, which also illustrate the gradual expansion of the Normal Building (later called Cranford Hall), show some of the young recently planted trees. When those trees matured they provided shaded walkways, which were proudly described in the school's promotional literature.

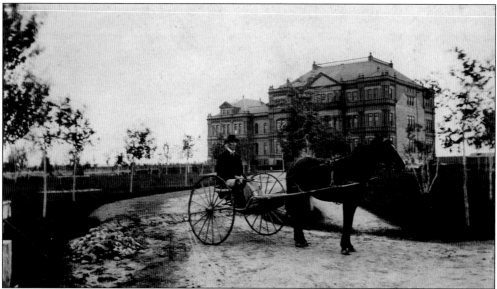

Louis Molner (class of 1895) and his horse, Maude, posed in front of the Normal Building, which is still lacking the west wing. For three years, Molner and Maude made the daily commute from their home in Eaton to attend classes at Normal, accumulating an estimated 6,000 miles of travel.

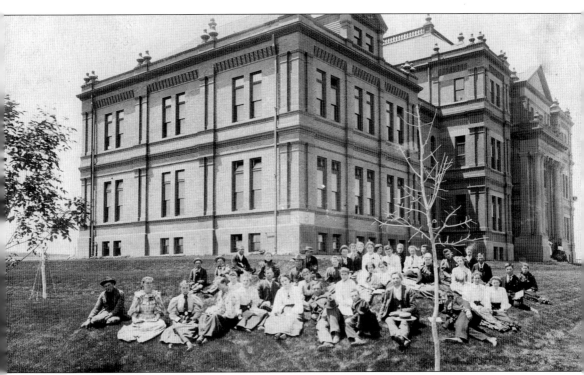

This class posed for its picture near the northeast corner of the completed Normal Building in about 1894. Originally the Normal School was a two-year program. Since a high school diploma was not required for admission, students often needed remedial instruction in the subject areas they would be teaching. In the final year, professional education courses were offered. In the early days, all classes were taught in the morning and students were expected to be off campus by 1:30 pm. This changed in 1895, when the head librarian decided to expand library hours to 4:30 pm. Students were still barred from campus on Sundays.

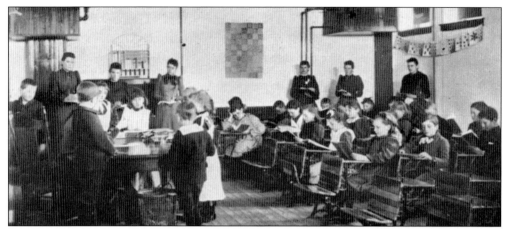

A model school, in which student teachers could observe working teachers in action and practice classroom control techniques, was a standard feature of normal schools in the late 19th century. SB 89-104, the 1889 founding legislation had provided that "a suitable practice department" should be a part of the proposed state normal school. On November 19, 1891, President Snyder was authorized by the board to begin organizing a training school. Miss Sarah Alice Glisan, who had recently graduated from the Normal School at Fredonia, New York, was hired to be principal. In fall 1892, forty-two students—representing grades one through eight—crowded into two rooms in the basement of the Normal Building. Teachers were Miss Glisan and the Normal School faculty, including President Snyder and the vice president, James Hays.

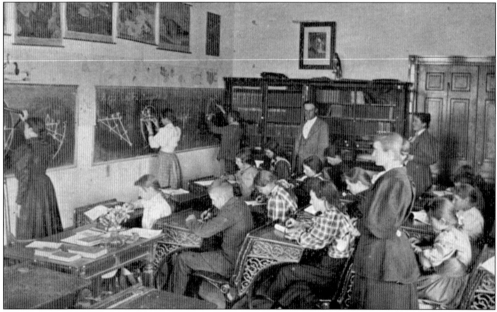

The following year, Miss Helen C. Dresser, an 1892 Normal School graduate, was added with some part-time assistance from normal students. In 1893, Miss Glisan married Nevin Fenneman, a teacher of geology, geography, and economics, and resigned. For the 1894–1895 school year, the west wing of Cranford was completed. The model school was brought out of the basement and given better quarters on first floor. More teachers were added, though Snyder and the Normal School faculty continued to teach.

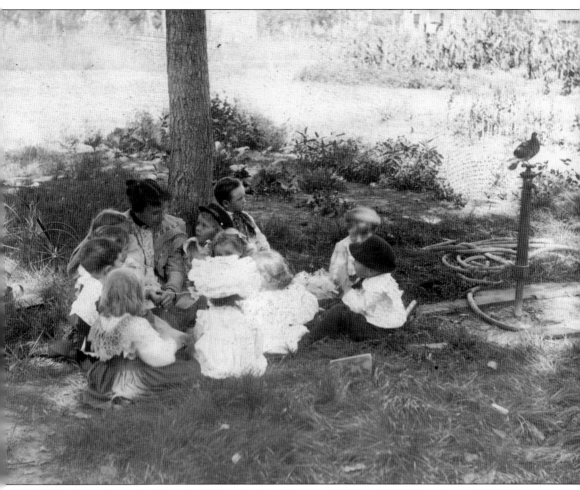

A kindergarten, the first in Colorado, had been added in 1892. Miss Laura E. Tefft, a graduate of the Froebel-Pestalozzi Kindergarten School of Berlin was hired to teach a class of kindergarteners, supervise the other kindergarten teachers, and teach a normal school class on kindergarten pedagogue. Miss Tefft's students addressed her as *"Tante* Laura" (Aunt Laura), and this 1894 picture beautifully captures the closeness of their relationship. The 1894 *Bulletin* reports that the school had 56 kindergarteners that year, while the total enrollment of first through eighth grades in the model school was on 75. Normal School enrollment was 314 students with 246 females and 68 males.

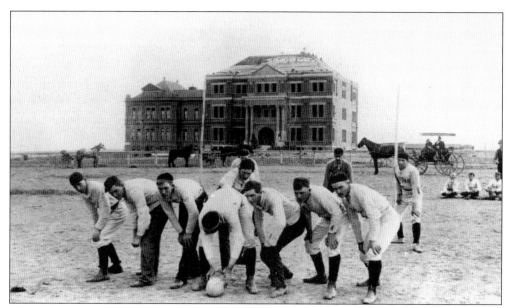

Sports have always been important on campus, but early football teams were hampered by the scarcity of male athletes attending the school. The first unpaid football coach was Pat Carney. The first game was played on this field north of the Normal Building. The first opponent is unknown but may have been a nearby town team or even a high school team. The game they played more closely resembled rugby than modern American football.

Later athletic events were held on a flatter playing field, eventually named Cranford Field, south of the Normal Building. The farmhouse on the horizon on the far right occupied the space where the University Center now stands.

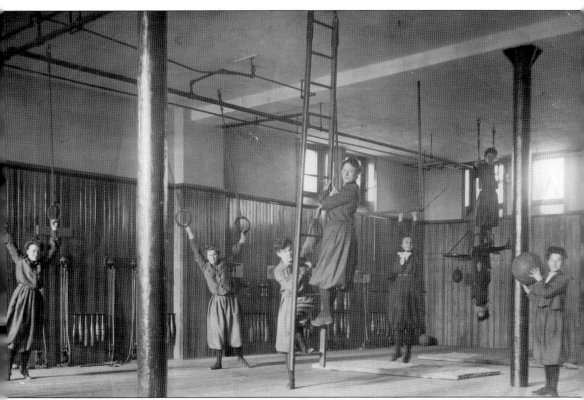

All students and faculty were required to be members of the Athletic Association. Gym classes and other indoor sporting activities were held in this gymnasium in the basement of the Normal Building's west wing, until 1918, when the Student Army Training Corps gymnasium was constructed. During these early years, women's physical education included focuses on fencing, marching, gymnastic games, and basketball.

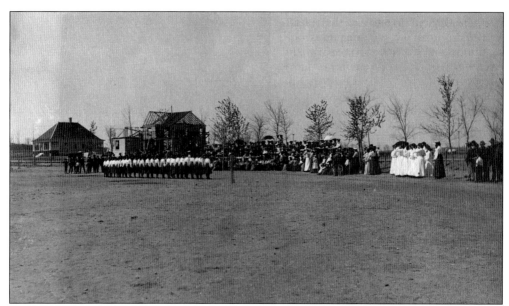

Since the college student body has always contained a larger percentage of women than men, women's sports have always been important, though until the 1960s there was no intercollegiate competition for female athletes. In 1907, when this picture was taken, women competed in basketball, baseball, tennis, archery, and track. The climax of the of the women's sports season was field day, usually held in May, at which female athletes had an opportunity to exhibit their skill to large crowds of spectators.

This image shows a men's track practice in the early days of Cranford Field. Hurdles, archery targets, and a high jump bar can be seen on the infield. The man at the far left is winding up to put the shot.

The 1900 normal school baseball team played its home games on Cranford Field. The baseball program would continue to expand through the years eventually becoming one of the most prominent athletic programs on campus.

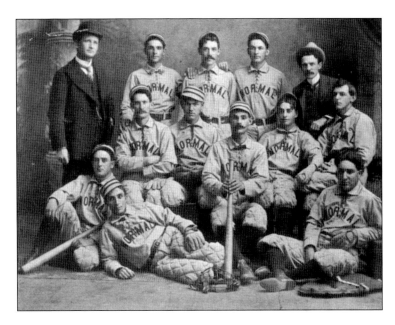

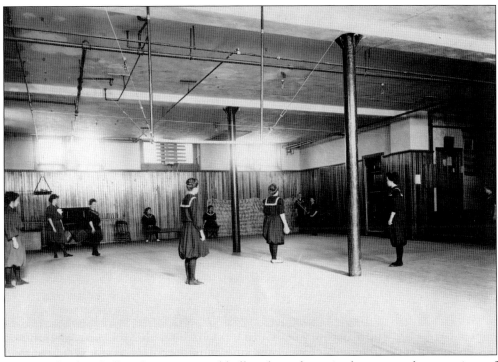

Women play baseball with an oversized ball and no gloves in the cramped gymnasium of the Normal Building basement.

Music was taught at Normal from the very first semester of its existence. In the first two decades, the music program was mostly devoted to glee clubs and chorales. Instrumental music was added later. In this photograph, Prof. John R. Whitman poses with one of his early women's glee clubs, around 1897.

In the late part of the 19th century, many communities celebrated Arbor Day with musical and dance programs and poetry recitations. President Snyder was an ardent promoter of Arbor Day. These performers were part of one such celebration in the late 1890s.

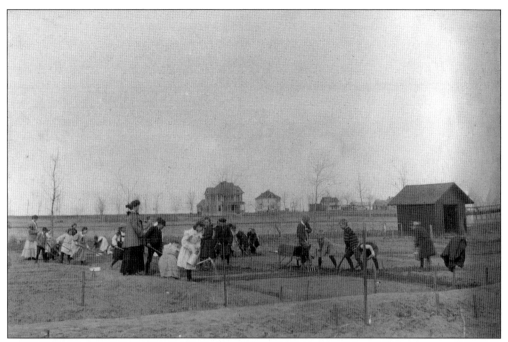

Standard primary education in the early 20th century tended to emphasize memorization and recitation, enforced by corporal punishment. Dr. Snyder was an early advocate of child-centered learning. He wrote, "How important, then, that the child be brought in constant, intelligent and loving contact with nature, the great storehouse of truth, the soul of all beauty and harmony." Training school students from kindergarten through the eighth grade cultivated gardens on the Normal School grounds.

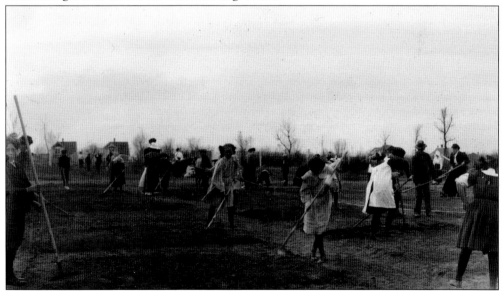

"[A teacher should] be able to lead a child to interpret its surroundings. A child must see the sparkling minerals and flowering plants; it must hear and see the buzzing insects and the singing birds; it must smell the fragrance of the rose, that it may admire and know and act," according to President Snyder.

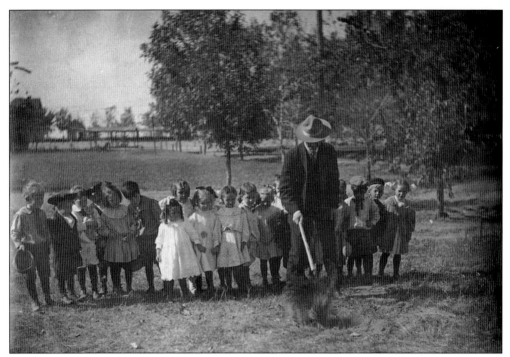

"The science excursion should be central, the all-important feature. The child must study nature as he finds it," explained President Snyder. These kindergarteners are not quite sure what to make of the visit of a porcupine on their excursion.

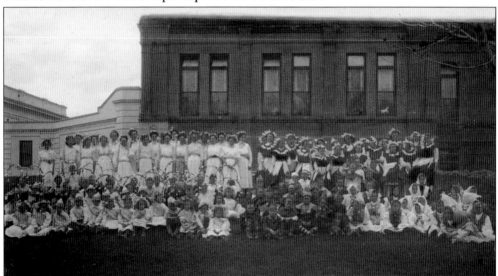

"Children were given contact with the world of things through excursions, nature study, and object lessons. They were stimulated to an appreciation of literature and life values by stories, myths, fairy tales, and legends; by bible stories presented as fine literature, by biography taught as a story instead of as an accumulation of facts. Such a programs was instituted for the model school nearly a quarter century ahead of its adoption by the public schools of the state," stated President Snyder. These Training School students dressed up for the Flower Festival, around 1912.

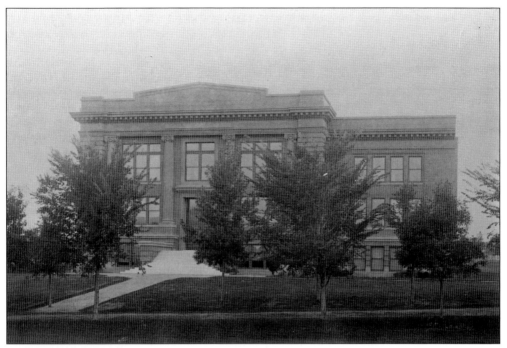

The Training School program added a high school in 1896. Enrollment quickly outgrew the small space allotted in the main building. In 1911, Kepner Hall was completed and the entire Training School relocated.

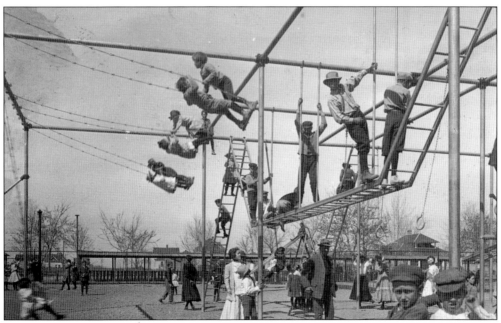

President Snyder's concept of child-centered learning recognized the importance of physical exercise in the education process. This playground was located just south of Kepner Hall. Playgrounds were an innovation in education in the early 20th century. One of the Normal School's first master's theses concerned the national playground movement.

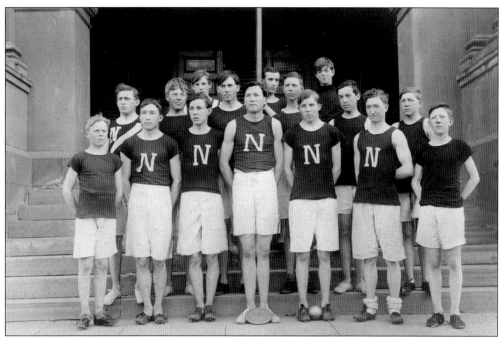

The students attending the Normal School's Training School not only took traditional academic subjects, but they were given opportunities to participate in extracurricular activities such as sports and drama. The model school's track team proudly poses on the steps of Cranford Hall.

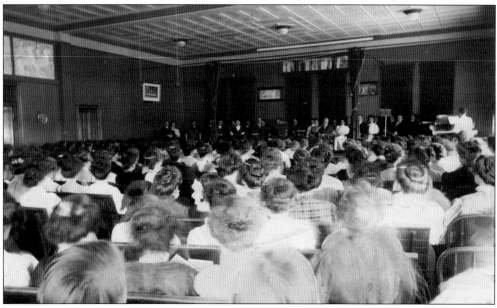

For many years, the largest assembly hall on campus was the 500-seat chapel located on the second floor, east wing of the Normal Building. The chapel was used for all student assemblies and meetings as well as dramatic and musical performances and lectures by visiting scholars. Billy Sunday, Vachel Lindsey, and Enos Mills all performed in the chapel. Later the chapel housed the Little Theatre of the Rockies. In this picture, President Snyder can be seen addressing an assembly of Normal School students.

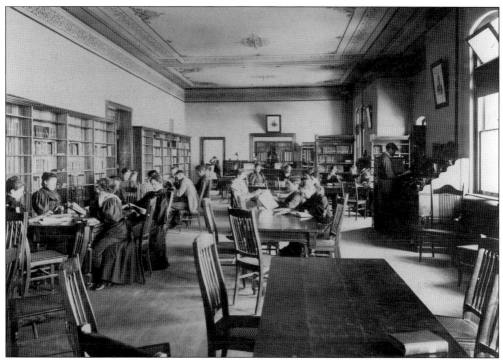

President Snyder recognized the importance of the library, and referred to it the "literary laboratory." In the early days of his administration, he personally selected most of the books that went into the library collection. In 1901, he appointed Dr. Joseph Daniels to be the school's first permanent librarian. Professor Daniels, a native of Massachusetts had originally come to Greeley to teach art history. This view of the normal school library was taken about 1904, when the library was located on second floor, center section of the Normal Building. Librarian Daniels is visible in his office at the far end. Less visible is assistant librarian Charles Needham, behind the circulation desk.

In 1905, Albert Carter was appointed as the school librarian. His first initiative was to begin lobbying for the construction of a new building to house the library's growing collection. A new library, with a dome and stained-glass windows, representing the nine muses of Greek mythology, was completed in 1907.

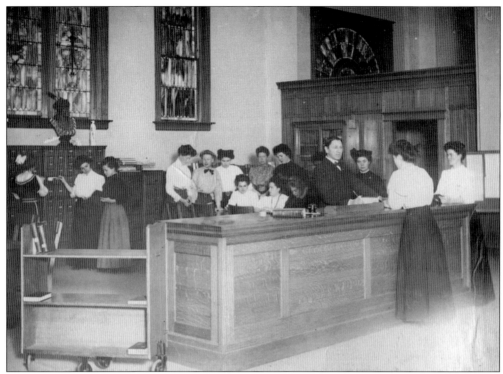

Dr. Carter, the library staff, and a number of students posed behind the circulation desk of the new library for this promotional picture used in the campus bulletins.

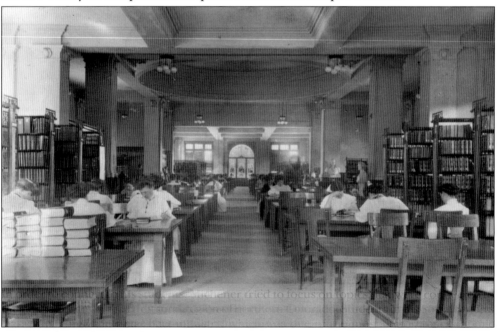

The main floor of the new building housed the library collections, which had grown to about 40,000 volumes at the time this picture was taken, and the lower floor housed a natural history museum. These students are studying in the main reading room under the dome.

This image was taken about the same time that an article in the *New England Journal of Education* (November 25, 1915) declared that President Snyder had assembled the "best Normal School Library in the world." The small sign in the lower left corner warns "Private property. Wagons and motorcycles KEEP OUT! Colo State Normal School."

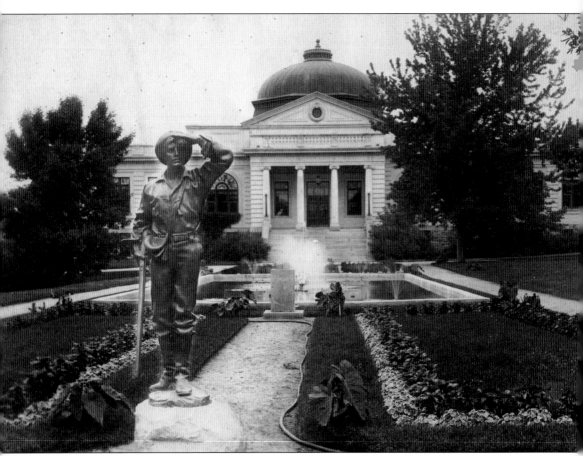

The reflecting pool was a gift of the class of 1911. The sculpture, a gift of the 1914 graduating class, was added at the end of the pool. Called the "Minuteman" by some and the "Pioneer" by others, he stood guard over flower beds, gazing northward from the entrance of the library down Ninth Avenue toward downtown Greeley.

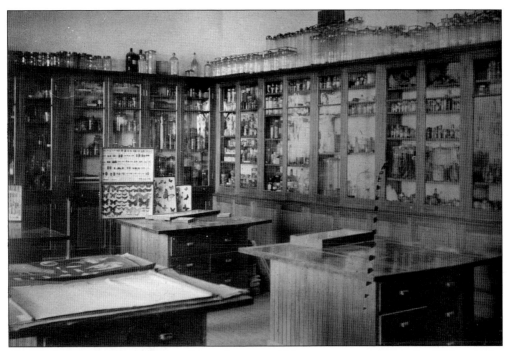

The basement of the new library housed a natural history museum. Several additional labs were housed in other buildings, including a psychology lab, a geography lab, and the biology lab seen here.

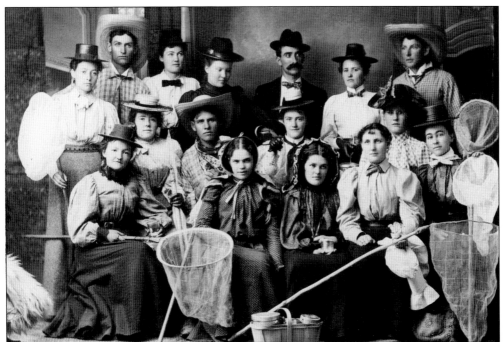

Normal School graduates were expected to teach the sciences through demonstration, including studying the local flora and fauna. These biology students are dressed and equipped for their science excursion, around 1900.

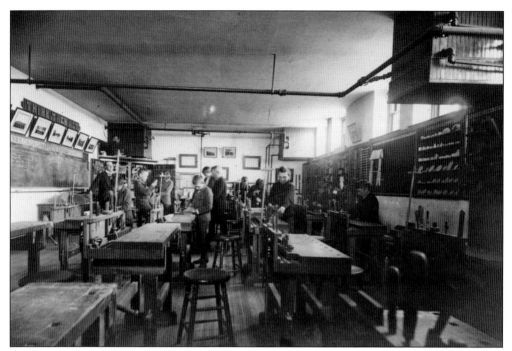

In the Training School, there was a heavy emphasis on teaching students practical skills ranging from the domestic sciences, such as cooking and weaving, to Sloyd. Sloyd was an educational system developed in Sweden that focused on teaching children to create a wide variety of hand crafts, particularly hand-carved items for use in the home. The system was designed to improve the children's character and encourage them to be industrious. The Sloyd laboratory on campus was created during President Snyder's tenure.

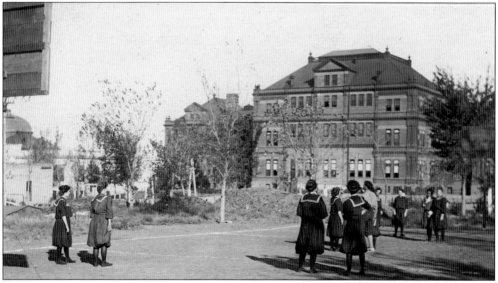

During the Normal School era, it was considered impolite, almost voyeuristic, for male students to watch women participate in sports such as basketball. The basketball courts were located on the south side of the Normal School Building. The photograph was taken around 1910.

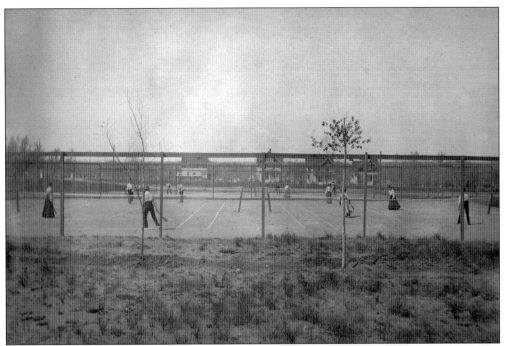

For certain sports, the prohibition of men and women competing together was lifted. Both tennis and shooting allowed mingling of the sexes. Tennis for both men and women has long been popular on campus. These courts were located southeast of the Normal Building.

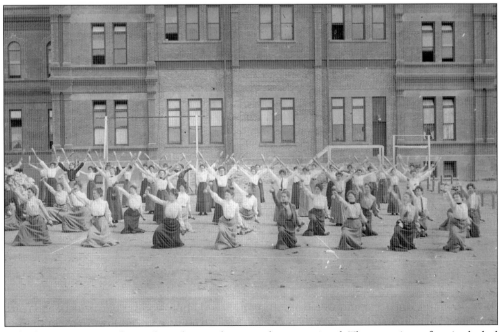

Calisthenics were performed outdoors when weather permitted. The exercises often included the use of a variety of props, such as dumbbells and clubs. These women probably did not know they were being observed by the gentleman in the second-floor window.

These students are performing a system of light gymnastics called "Delsarte." The benefits of Delsarte were intended to be cross-disciplinary. The 1891 *Bulletin* described it as "that particular training . . . whereby students are put in possession of their bodies . . . the individual is led to have unconscious control of himself."

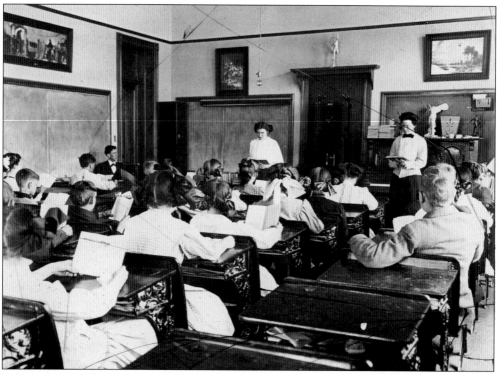

It was assumed that teachers would be spending a lot of time reading aloud to student and Delsarte training was supposed to impart an unconscious control over gestures, posture, voice modulation, and so on. The 1894 *Bulletin* said, "how it charms one whose speech has grace and ease—what an element of government . . . A refined thought is not all. There must be refined expression, refined voice, refined speech, refined action." These student teachers are putting into practice the unconscious body control they learned in Delsarte.

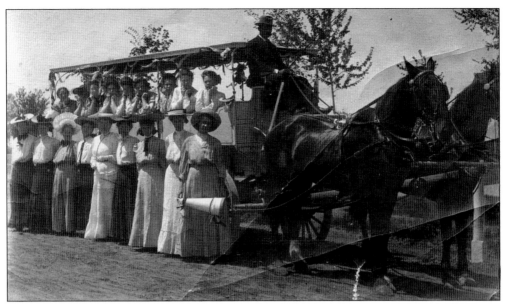

The first two fraternities on campus were Delta Psi and Lambda Gamma Kappa, both of which were organized in 1903. Sororities soon followed in 1905, the first being Delta Phi Omega, quickly followed by Sigma Upsilon. The women in this photograph are from Sigma Upsilon preparing for a sorority outing in 1907.

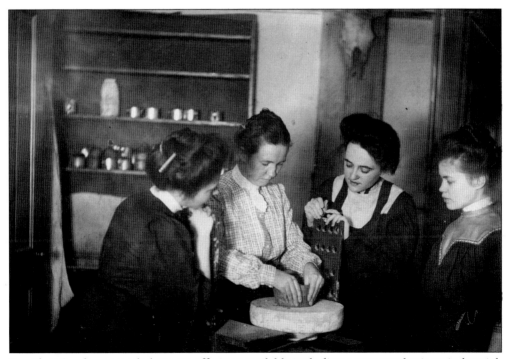

President Snyder expanded course offerings available including a new emphasis on industrial, fine, and domestic arts. The school was one of the first in the country to emphasis the creation of ceramics. These women are working in a ceramics laboratory in the Normal Building.

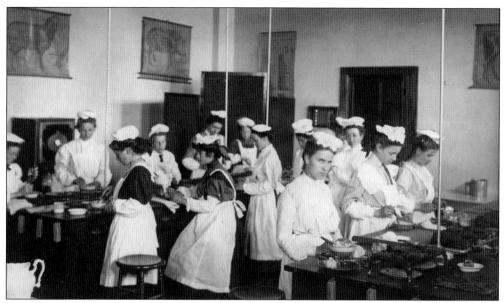

The domestic sciences movement began in the mid-19th century but gained prominence in schools and colleges during the early 20th century. The movement aimed to provide a scientific basis for a variety of household activities, including improving nutrition and hygiene. The domestic science department at the normal school offered a wide variety of courses such as the effect of heat upon food; canning, pickling, preserving, marketing; and the study of textiles.

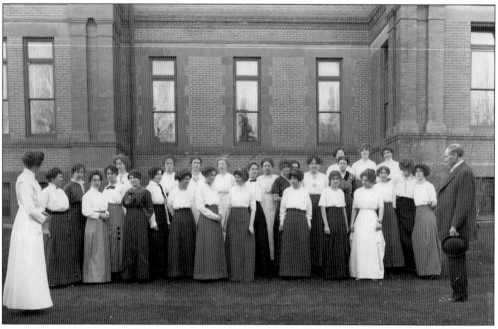

President Snyder expanded the course offerings available including a new emphasis on industrial, fine, and domestic arts. He invited his son-in-law, Samuel M. Hadden, an expert in vocational education, to supervise parts of the program. Snyder is seen here inspecting the clothing created by a group of domestic sciences students.

Despite this lampoon of the home economics students printed in the 1910 *Cache la Poudre* yearbook, the domestic science department provided popular elective courses for the students.

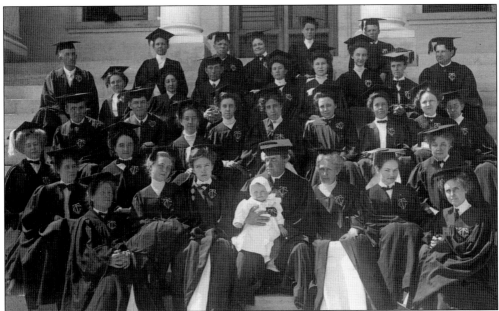

A common fad among classes in the early 20th century was to "adopt" a child of a favorite faculty member as a class mascot. Pictured here is the graduating class of 1910 with its class baby, Margaret Snyder Hadden, daughter of industrial arts professor Samuel Hadden and granddaughter of president and Mrs. Snyder.

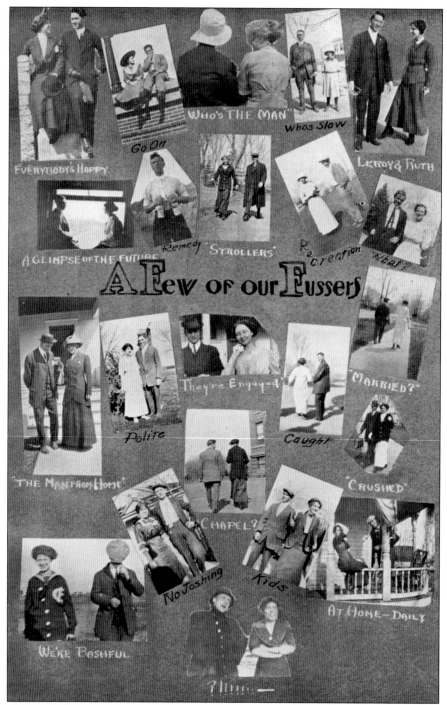

"Necking," "making out," "sucking face," each generation of students has its own term for that universally popular pastime. In these students' day, it was referred to as "fussing." The most popular make-out spot for CTC students was a small park a few blocks south of campus, near where the University Center is currently located. The 1913 *Cache la Poudre* carried this tribute to a few popular couples on campus, who presumably had been observed fussing.

Due to President Snyder's membership in the National Simplified Spelling Board from 1907 to 1915, all of the schools followed the board's recommendations for correct spelling. These reforms included removing silent letters, generally removing double consonants and replacing past tense "ed" with "t." Although some of these practices became standard within American English, the campus returned to more traditional spelling conventions, after Snyder's death in 1915.

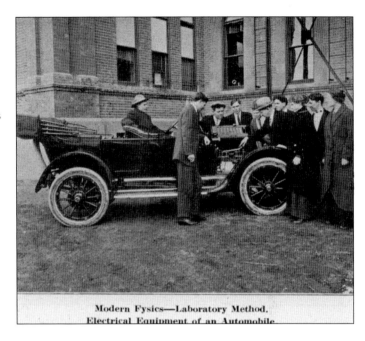

Modern Fysics—Laboratory Method.
Electrical Equipment of an Automobile.

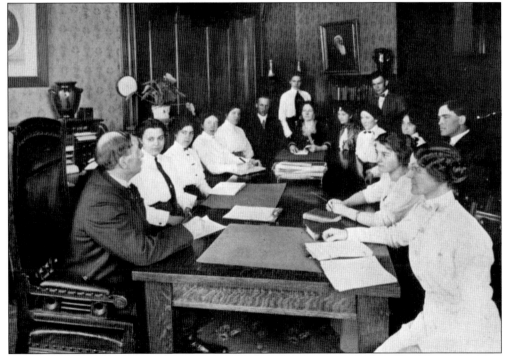

The first experiments with student self-government occurred in Dr. Snyder's presidency. The first student body president was Lyra Kennedy, who had been elected on a suffragist ticket, shown here presiding over a meeting in the president's office. In the days of the omnipotent college president, student cabinet provided students with a voice on issues of grading, curriculum, and student discipline.

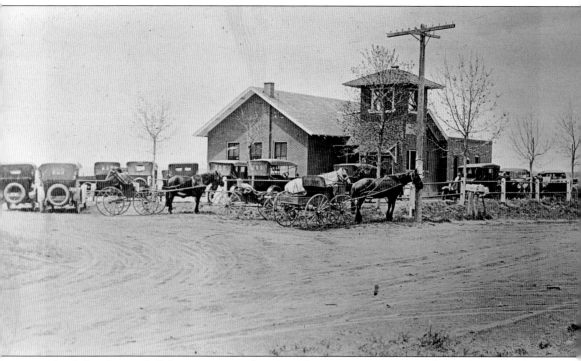

The Colorado Rural Club was organized in 1915. This was an organization for students enrolled in a program designed for future teachers in rural schools. Some normal school students did their student teaching in the Hazelton School, pictured here, which was located about 10 miles west of Greeley. The building still survives but has been moved from its original location to the Poudre Trail Corridor where it now houses the Poudre Learning Center.

Two

STATE TEACHERS COLLEGE OF COLORADO

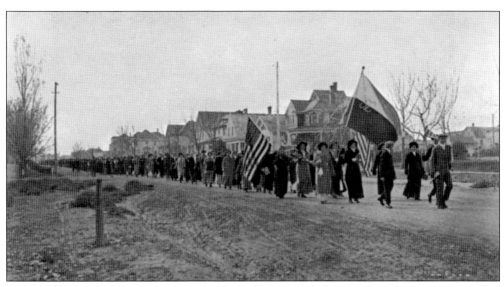

In 1911, the standard program expanded from three years to four, and graduates were awarded the degree of bachelor of pedagogy. The move enhanced the institution's academic status, and it was renamed Colorado State Teachers College. This celebratory procession of students and faculty is marching north on Tenth Avenue from the campus toward downtown Greeley. The leaders have just passed the intersection of Tenth Avenue and Sixteenth Street.

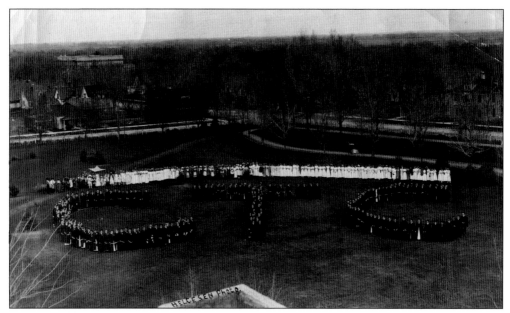

Students posed for a photographer, located on the roof of the President's House, on Insignia Day 1913. Insignia Day was a formal recognition of outstanding scholars on campus, and caps and gowns were mandatory.

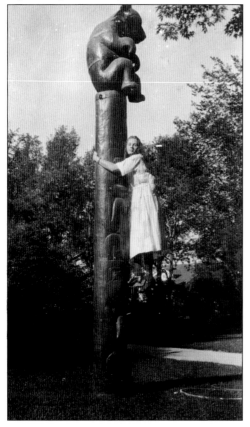

In 1914, "Totem Teddy," a brown bear totem created by the Bear Clan of the Tlingit people of Alaska was donated to the institution by Andrew Thompson, class of 1897, who was serving as U.S. Commissioner of Education in Alaska. Totem Teddy was one of the last native sculptures removed from Alaska before the law prohibiting removal of native artifacts went into effect. Like the Minuteman, he was a symbol of the institution and lived at several different locations until 2003, when he was finally repatriated.

After President Snyder died in 1915, the board of trustees named John Grant Crabbe to the presidency. Crabbe had served in the public school system in Kentucky as a state superintendent of instruction and had been president of Eastern Kentucky State Normal School. He would continue President Snyder's commitment to producing excellent educators at the college.

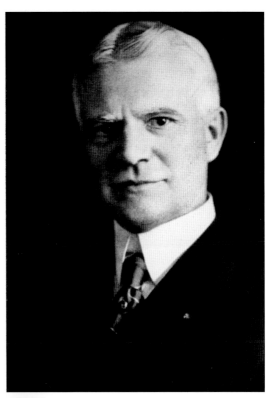

Along with numerous other buildings on campus, construction began on the Home Economics Building in the early 1910s. The building was completed in 1919 after several years of construction and would later be renamed after President Crabbe in 1931.

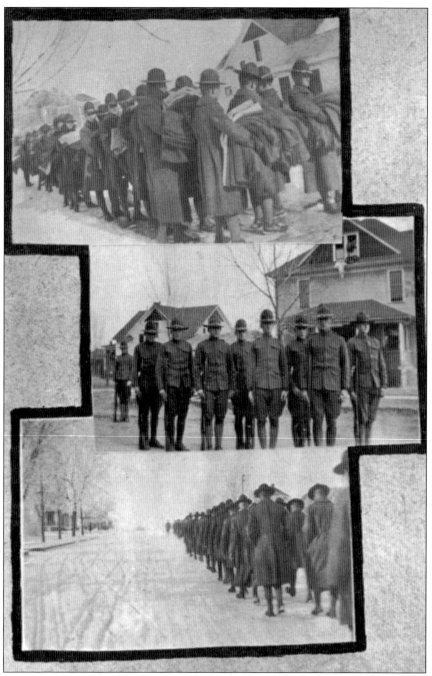

Reduced wartime budgets inspired President Crabbe to contract with the War Department to initiate an education program for active service men, the Student Army Training Corps (SATC). The men were housed in college-owned fraternity houses, which had been vacated for them. SATC men were enrolled in courses in the French, German, and European history. These pictures show them lined up receiving their bedding and moving into their quarters. The presence of the SATC men was good for the sports teams. The 1918 football team defeated the University of Colorado, 9-0, and Denver University, 26-7.

This building, known affectionately as the Old Green Gym or the Old Barn was built south of the Normal Building (Cranford Hall) for the SATC men. It stood until about 1927 and was used for basketball games and wrestling meets. It also served when any large space was needed to accommodate large gatherings, such as student registration, large lectures, and even music and dramatic performances.

The interior of the Old Green Gym was never finished, as shown in this 1927 photograph. For the ten years or so that it was on campus, it was just studs and rafters. Perhaps the most famous visiting performer showcased in the Old Gym was Madame Ernestine Schuman-Heink, the opera contralto, who performed there on February 24, 1922. The *Cache La Poudre* for that year reported, "She was appreciated by all music loving people in spite of the omission from her program of the most popular American classic, 'Ain't We Got Fun.'"

Much of the money needed for construction of Guggenheim Hall came from U.S. senator Simon Guggenheim. The building was constructed in 1912 under the direction of President Snyder. The hall housed programs in fine arts and art history.

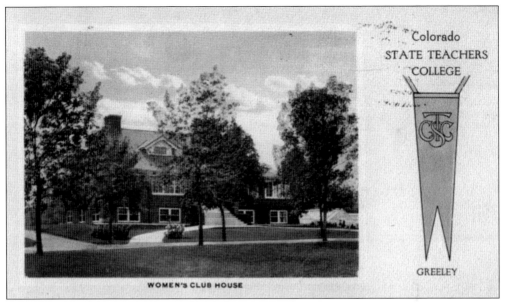

WOMEN'S CLUB HOUSE

In 1912, campus women began to push for an exclusive female-only space where they could gather and hold social events. The Women's Club House was completed in 1916. Until 1923, male students were not permitted in the club house unless they were escorted by a chaperone. It was remodeled through the years, transforming from the Women's Club House to the Student Club to the Student Union, and it is now known as Gray Hall.

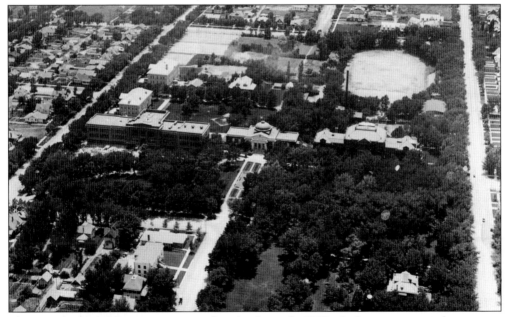

This aerial view of the campus was taken in the early 1920s. In it, one can see that mature trees that had been planted by President Snyder are now shading the campus sidewalks. In the center is the domed library, flanked on the right (west) by Old Main (Cranford Hall) and on the east by the Training School. In the lower right corner is the President's House, which later became the Music Conservatory. Behind Cranford are the Old Green Gym and the football field.

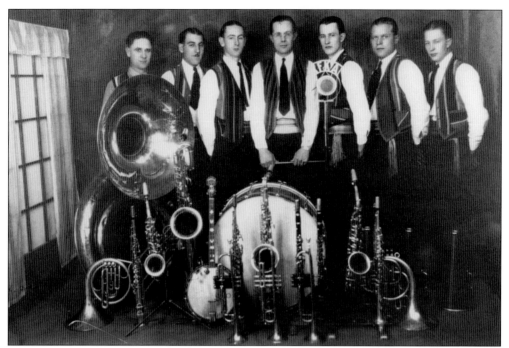

Students formed the Wireless Club in 1914 to study the science and practice of wireless and radio operations. During 1925, the club worked in conjunction with the physics department to create the 100-watt radio station KFKA. It was originally broadcast from Cranford Hall but soon moved to the Conservatory of Music where the department of music took ownership of the programming. The operation of "Greeley College on the Air" soon became too burdensome for the college, and the station was taken over by a private company.

The Home Economics Practice Cottage (now Roudebush Hall) was completed in 1915. For many years, high achieving Home Economic students were invited to live in the cottage for a term and practice the domestic skills they had learned in the classroom.

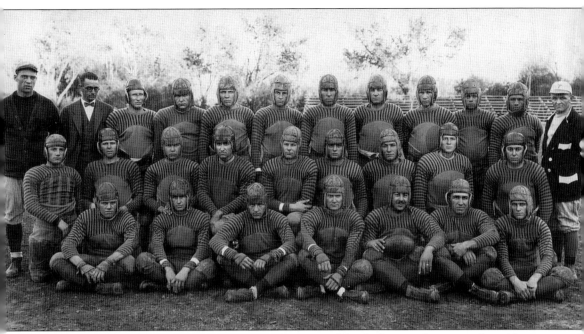

George Cooper, on the far right posing with the 1926 football team, began as the athletic director of the Colorado State Teachers College in 1922. He would serve as the head coach for football, basketball, and baseball throughout the 1920s. John Hancock Jr., standing on the far left, replaced Cooper and served as a coach and director until his retirement in 1966. Hancock played a pivotal role in shaping the athletic program during his time at the college.

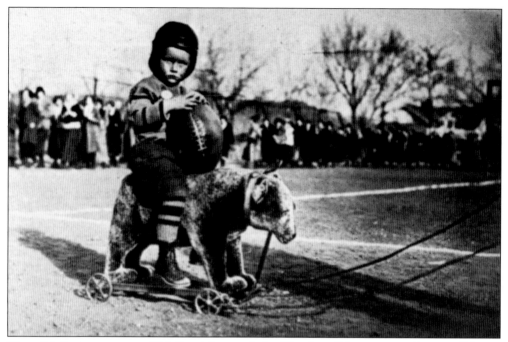

The athletic teams were officially nicknamed the "Teachers;" however, in honor of Totem Teddy, a bear was an unofficial symbol. The first homecoming celebration was held on November 24, 1923. The fans paraded into the stadium led by young Bobby Cooper, son of head coach George Cooper, mounted on this toy bear, which made Bobby and the bear the first homecoming float. Bobby's face reflects the outcome of the game, Montana State 49-Teachers 12.

By 1925, it was evident that Cranford Field was inadequate for intercollegiate athletics. The college had been lobbying for admission into the Rocky Mountain Conference, and a more modern stadium was necessary. Land east of Sixth Avenue was purchased for that purpose. The new stadium was named after Charles N. Jackson, a member of the board of trustees, who helped finance the property. Dedication of Jackson Field was on October 1, 1927.

52

Homecoming continued to be a tradition on campus throughout the years, although in the early years, the Bears were not necessarily a football powerhouse. The team lost to the Colorado Aggies 33-0 in the 1927 game.

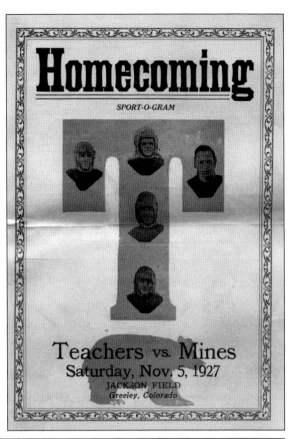

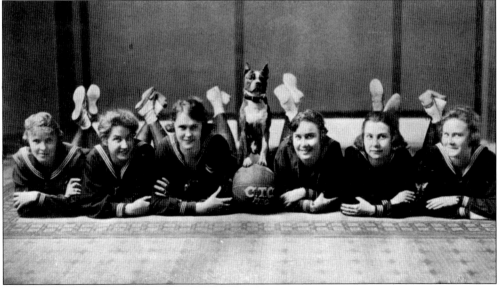

The Women's Athletic Association and the Physical Education Association were primarily responsible for women's athletics on campus. Women's teams were generally intramural and included such diverse sports as archery, baseball, field hockey, and basketball. The 1920 basketball team poses with its unidentified mascot.

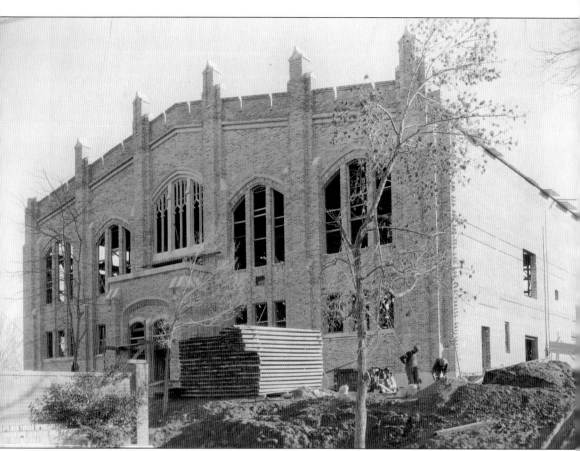

Construction of Gunter Hall of Health began in 1926 to serve as a focal point for the athletic program. The Gothic-style building was named for Colorado governor Julies T. Gunter and contained a swimming pool, separate men's and women's gymnasiums, and a number of classrooms. It was dedicated in 1928 in a ceremony that included a basketball game between the University of Colorado and the CTC Teachers.

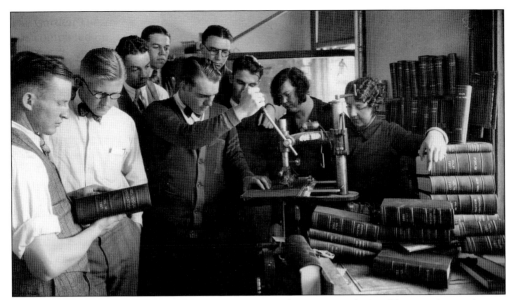

In the mid-1890s, the Normal School administration began considering library science classes, particularly courses focused on the establishment of school libraries and training of school librarians. By 1905, the program was established, and students who wished to focus on school librarianship could take courses ranging from book buying to library government. Bookbinding, as seen in this 1928 class was one of the foundational courses in the program.

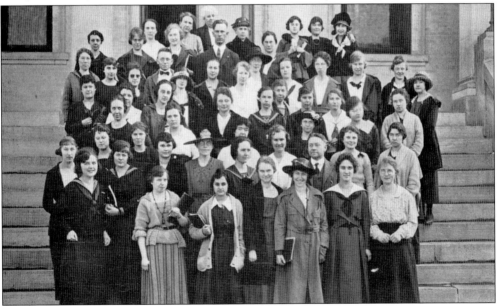

The *Bulletins* of the 1920s call the college non-sectarian but were anxious to reassure potential students and their parents that Christian values were promoted. There were a variety of religious organizations including the YWCA and the Newman club. These students are enrolled in a program called Bible Study under the Greeley Plan, which was a collaboration between CTC and several Greeley Protestant churches that allowed students to earn college credit by teaching Sunday school classes. The program had 150 students in the 1919–1920 school year and 235 in the 1921–1922 school year.

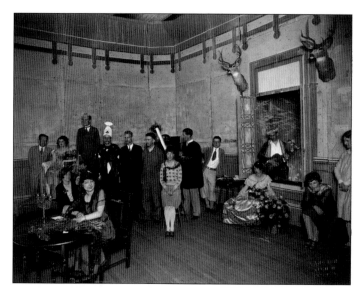

Drama was an important aspect of the institution since its founding. Starting in 1900, the senior class annually presented plays for the campus and the community. The dramatics club, which formed in 1914, produced several plays every year. The club presented the play *You and I* in Cranford Hall's chapel during the 1928 academic year.

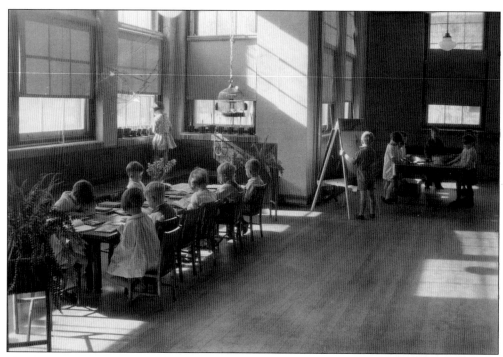

The focus of the school continued to be firmly in the production of teachers. The Training School in Kepner Hall was an essential part of the teacher training programs. The school enrolled children from kindergarten through seniors in high school. This image shows the kindergarten students, in the 1920s.

There was a wide variety of student organizations at the college, including numerous departmental clubs. The art club, which was established in 1905, was one of the first such organizations on campus. The motto of the club was "Art First, Science Later." Members of the 1920s club are posing on the steps of Guggenheim Hall.

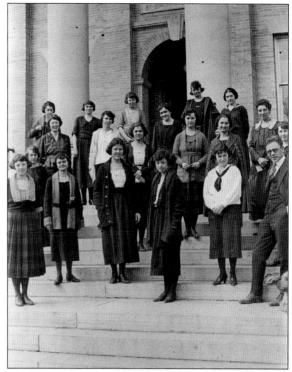

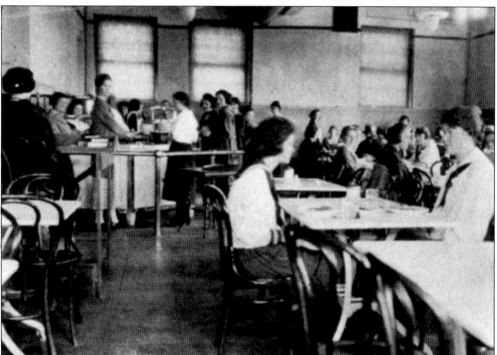

This 1923 photograph shows the first college-run cafeteria on campus. It had originally been installed on the first floor of the Home Economics Building (Crabbe Hall) to feed the SATC men. Later, staffed by home economics students, it was open to all.

In 1924, President Crabbe died suddenly of a heart attack and was replaced by this man, Dr. George Frasier, a 33-year-old Columbia University graduate. President Frasier was so young looking, according to the 1928 *Cache La Poudre*, that he was once mistaken for a new freshman and dunked into the reflecting pool in front of the library, which was a common fate of freshmen in those days.

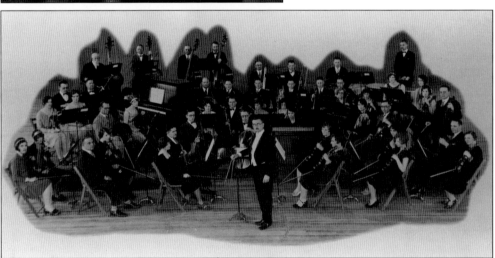

The Greeley Philharmonic Orchestra is probably the best known and most respected collaborations between the school and the city of Greeley. It was organized in 1911 by Professor John Clark Kendall. In this 1927 photograph, its leader is J. DeForest Cline, who was head of the Music Conservatory from 1924 until 1949. Cline is best remembered as the composer of the school's Alma Mater, "Ah, Well I Remember."

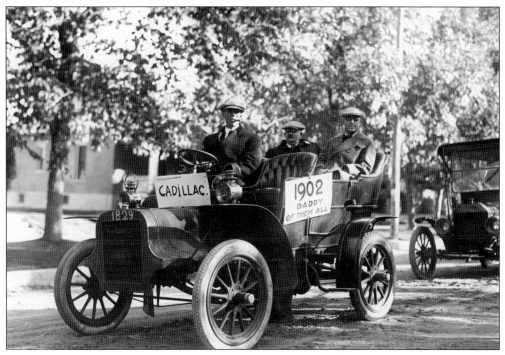

President Frasier rode in this 1902 Cadillac in the 1927 homecoming parade.

One short-lived experiment in adult education, under President Frasier, was a weeklong "School for Custodians, Janitors and Engineers" in the summer 1927. Students received training in overall building and grounds maintenance, not just sweeping and cleaning. The photograph on this brochure is a rare interior shot of the campus heating plant that was located between Cranford Hall and Cranford Field.

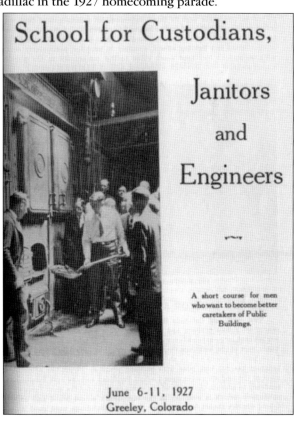

School for Custodians,

Janitors

and

Engineers

A short course for men who want to become better caretakers of Public Buildings.

June 6-11, 1927
Greeley, Colorado

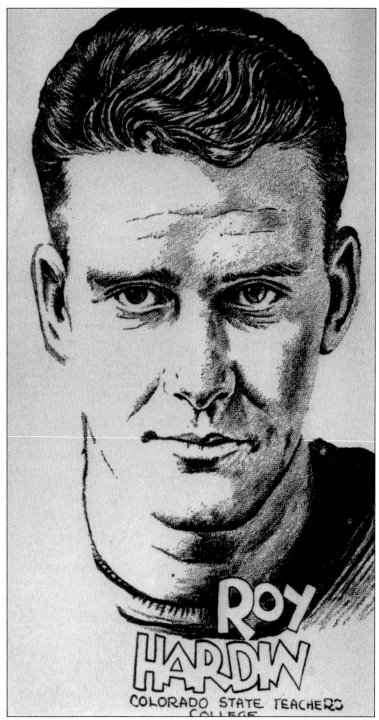

ROY HARDIN

COLORADO STATE TEACHERS
COLLEGE

Roy Hardin was the Bears' quarterback during the early 1930s. He was one of the "Eleven Iron Men" who played for Coach Hancock. In 1934, Hardin was an All-American honorable mention quarterback, All-Conference back and third in the nation in scoring. He went on to sign with the New Jersey Panthers in 1937.

60

Three

COLORADO STATE
COLLEGE OF EDUCATION

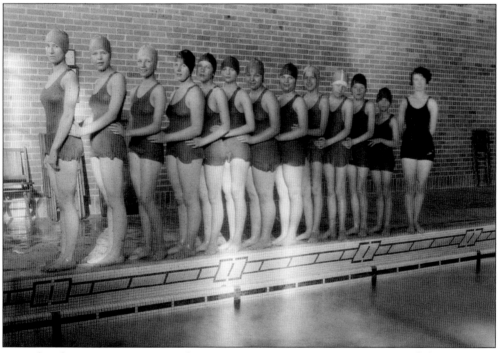

As with other women's sports, the women's swimming team was part of the Women's Athletic Association. The swim team did compete against other colleges but was considered a recreational activity. Women who passed the required swimming test required to initially join the club were known as "Mud Turtles" and were not considered full members. Only after reaching a certain level of proficiency were the women officially inducted as "Dolphins" into the team.

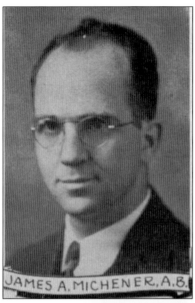

JAMES A. MICHENER, A.B.

Prior to his successful writing career, James A. Michener taught social studies. He received his master's degree in secondary education in 1937 at CSC and taught at the progressive College High from 1936 to 1941. During his time in Greeley, he began formulating interests in ideas that he would later address in his novel *Centennial*.

In order to connect to his students, Michener tried to focus on topics that were connected to their experiences in the fairly rural region of northern Colorado. Students in his Social Studies classes explored the sugar beet industry, which was one of the most important economic factors in Greeley, in a wide variety of methods including lectures, discussion, and listening to music. The experiences led Michener to write an article titled "Bach and Sugar Beets."

The Hays Picnic was an annual springtime event named for Vice Pres. John Hays. He had supposedly called for a spontaneous holiday one spring day during a difficult year. Everyone on campus was invited to attend the picnic, wherein the faculty cooked the food and served it to the student body. The tradition continued on campus until the 1960s. In this photograph, James Michener is seen attending one of the picnics sometime around 1937.

Helen Langworthy came to Greeley for a temporary position in College High. President Frasier requested that she develop a dramatics program to accompany the summer school sessions. Under her direction, the Little Theatre of the Rockies was launched in 1934. Due its success, her temporary position was transformed into a permanent post. She would lead the LTR until her retirement in 1965.

During its first season, the Little Theatre of the Rockies presented a total of eight plays on campus and four in nearby Estes Park. The LTR eventually took over the production of plays from the Dramatics Club and provided opportunities for drama students to work with professional actors. Here Patricia Challgren portrays Viola in the 1935 production of *Twelfth Night*.

Several student publications have been produced throughout the institution's history. The original student newspaper was called the *Crucible*, and it was published from 1892 though 1920. The *Mirror* took its place in 1921, and it continues to be published. The student yearbook began in 1907 and was called the *Cache la Poudre*.

Lonis "Pete" Butler was a star basketball, baseball, and football player at CSTC. He received numerous awards throughout his athletic career, including 11 college letter-sweaters. After he graduated, he soon returned to coach the CSTC basketball and baseball teams leading them to numerous victories.

As the athletic program on campus grew, a student marshal was elected to boost school spirit. The campus community elected Dean McCoy as the marshal for the college in 1931. McCoy, along with his two "yell leaders," was responsible for coordinating all of the pep rallies and cheering during the home games.

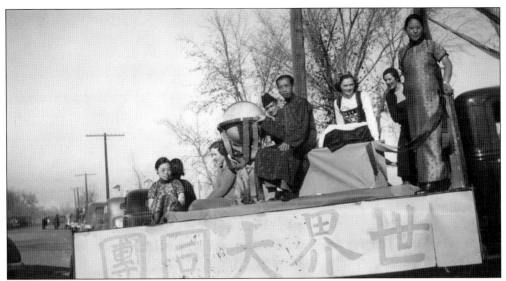

As part of a campus movement focused on internationalism, Cosmopolitan Clubs were founded throughout the United States. The mission of these organizations was to promote communication and understanding between peoples of differing nationalities, ethnicities, and races. The first attempt for a chapter of the Cosmopolitan Club at the Colorado State Teachers College was in 1921, but it was not until late 1927 that the club grew. For the next 13 years that the club operated, it included hundreds of members from all around the world, nation, and region. The club's 1936 homecoming float displays the club's motto "Humanity above All Nations" in both Chinese and Arabic.

The need for a strong support staff grew along with the development of the campus. As with most modern institutions, a great deal of the documents are generated in the daily operation of business. Much of this material has been transferred into the care of the archival services department. Therefore the records handled by the president's staff in the 1920s are likely still available for research.

Music always played an important part of the school. There were a variety of music organizations including glee clubs, mandolin clubs, and choirs. The 1931 Women's Octet, pictured here with its accompanist, performed vocal music on both campus and in the community.

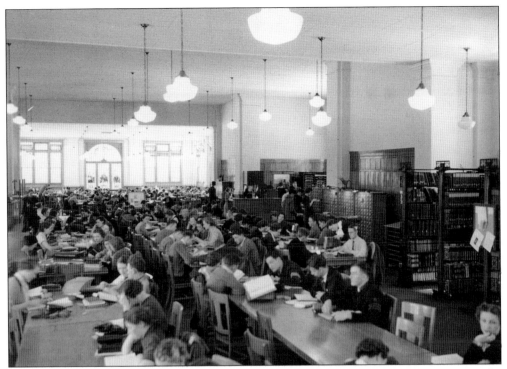

By the late 1930s, expanded enrollment and growing collections were starting to strain the capacity of the library. This picture illustrates the overcrowding in the main reading room.

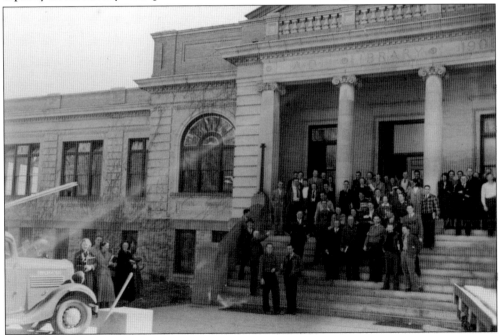

Begun in 1938, a two-year $50,000 library remodeling project was undertaken with funding from the Public Works Administration. This crowd of students, faculty, and college staff gathered on the steps of the library to observe the ground breaking ceremony.

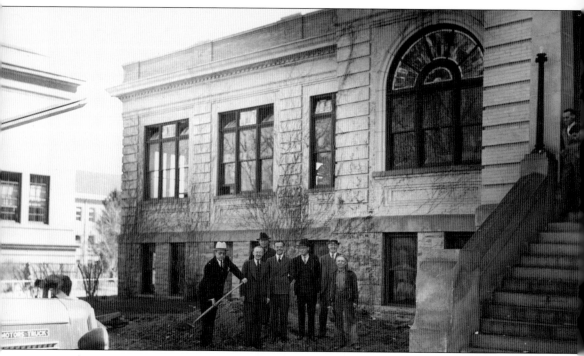

President Frasier turns the first shovelful at the ground breaking of the library remodeling project. The expansion, which was designed by architect F. W. Ireland, cost over $300,000. The new library could house 275,000 volumes.

The library
staff posed
for a publicity
photograph in the
spiral staircase
in the newly
remodeled library.

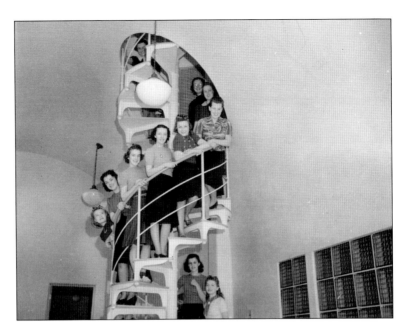

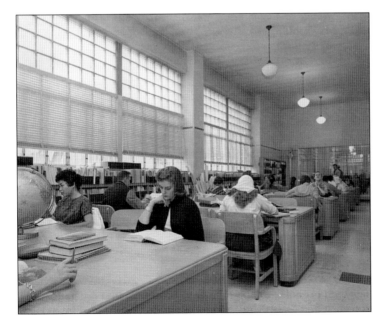

Remodeling resulted
in the loss of the
unique and beloved
dome, the stained-
glass windows, and
the reflecting pond.
However both the
book storage capacity
and the seating
capacity doubled.
This photograph
shows the newspaper
reading room after
the remodeling.

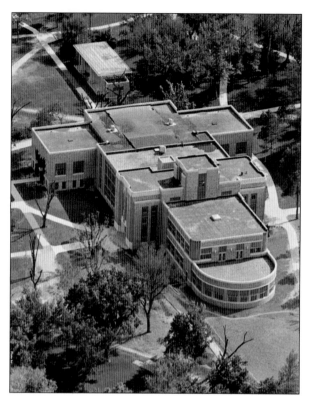

Expansion completely covered the space that had once been occupied by the reflecting pool and the minuteman statue. The fate of the Minuteman is unknown. In 1922, he had been kidnapped. He was found several months later in a muddy ditch outside of Greeley, with his rifle hand damaged. The latest picture of him in his customary station is dated 1928. However when the library was remodeled in 1938 and the reflecting pond removed, there is no record of whether the Minuteman was still there or what became of him if he was. Some say he was buried on the spot and still remains interred beneath the north wing of Carter Hall. Some say he was donated to a World War II scrap metal drive.

Except during the war years, Greek houses have always played an important role in campus social life. President Snyder himself was skeptical about fraternities and sororities. They were considered to be exclusive clubs for elites, with arcane rituals and little educational value. This picture was taken in Estes Park on an outing sponsored by Epsilon Tau in 1936.

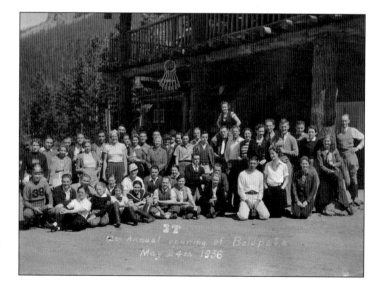

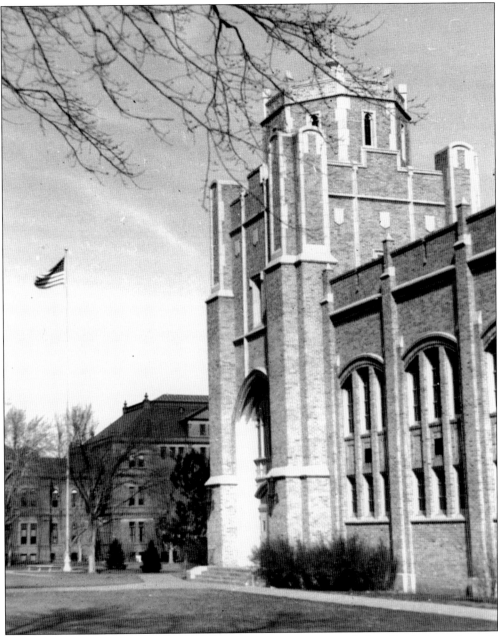

Leo Florio, an Italian immigrant, presented the CSCE campus with the gift of a large flagpole on the central campus. Florio wanted to recognize the many opportunities afforded to immigrant communities, particularly the Italian community, in the United States. The flagpole was rededicated to Florio in October 1990.

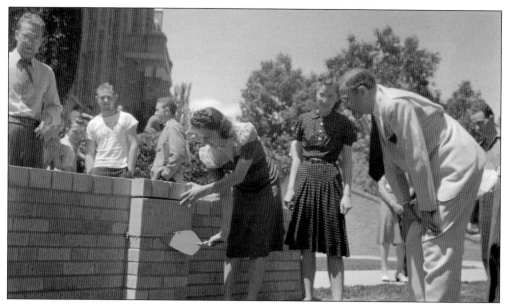

Graduating student bodies often gave a gift to the campus. These gifts have included the reflecting pool in front of the Carter Library (class of 1911), the east gate (class of 1912) and the Pioneer/Minuteman statue in front of the library (class of 1914). The class of 1940 presented a bridge near Gray Hall. It became known as "Hi Bridge," which according to the 1959 *Cache La Poudre* yearbook was the "friendliest spot on campus."

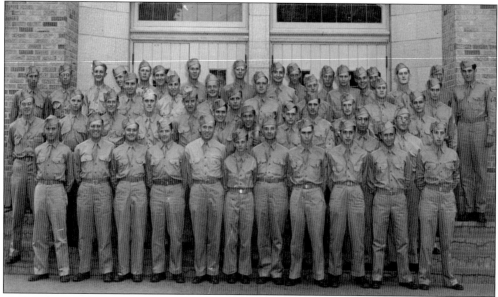

As had happened during the World War I, dwindling budgets required drastic action. President Frasier contracted with the war department to train 400 U.S. Army Air Force enlisted men to be clerks and typists. Dr. William Ross was vice president of building and planning at the time and to him was awarded the task of finding housing, bedding, and furniture for the men. In his memoirs, he describes the difficulties he encountered acquiring the lumber to make bunk beds, dining tables and typing tables in wartime. Once found, the work of building these was done on campus by the Industrial Arts department.

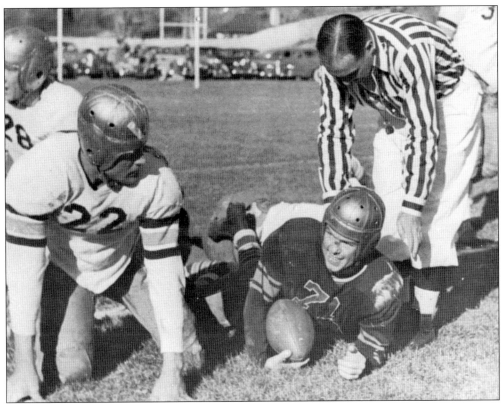

Second-Team All–Rocky Mountain Conference tailback Bobby Fliegan was CTC Athlete of the Year in 1942.

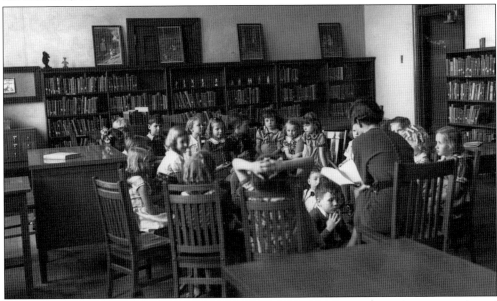

A library was added to the training school in 1924. Elementary school students are gathered there listening intently to a story, around 1943. The University Libraries continue to serve the needs of children and houses a large youth collection.

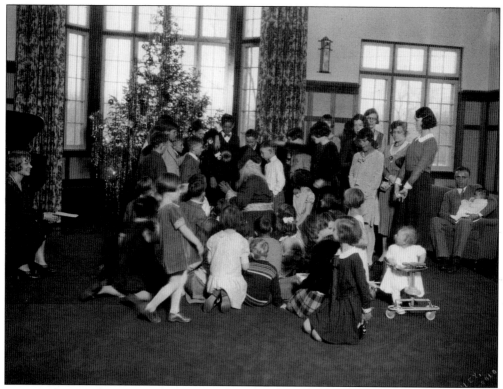

This photograph shows a Christmas party underway in the faculty apartments. The first faculty apartments were completed in 1930. On the right, the man seated with the baby is J. S. "Dobby" Doubenmier, the laboratory school athletic coach. He attempted to remain in contact with many of the college alumni during World War II. He sent letters and newspapers to men stationed all around the world.

"Whoso Teaches a Child Labors with God in His Workshop," says the inscription over the entrance to the Training School in this image around 1941.

A veterans organization called DO-GO-MA, (doughboys, gobs, and marines) helped returning service men and women readjust to civilian life. Many veterans used the GI Bill to help finance their education. These new students wanted to see a broadening of the college's academic programs beyond teacher education.

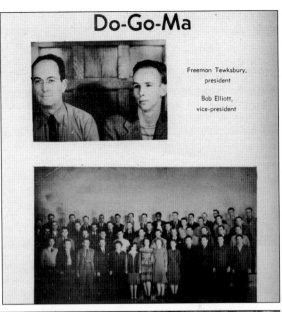

Do-Go-Ma

Freeman Tewksbury,
president

Bob Elliott,
vice-president

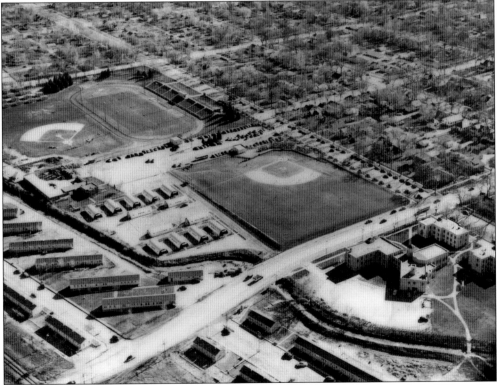

With the war's end, enrollment expanded as veterans rushed to cash in their GI benefits. Providing adequate housing for these men and women, many of whom were married and had children, was Vice President Ross's greatest challenge. This *c.* 1950 aerial photograph of Jackson Field shows the double Quonsets, which were placed east of right field on the baseball diamond and some of the prefabs on wheels to the east and north. Land was purchased between the railroad and the No. 3 irrigation ditch for housing purposes.

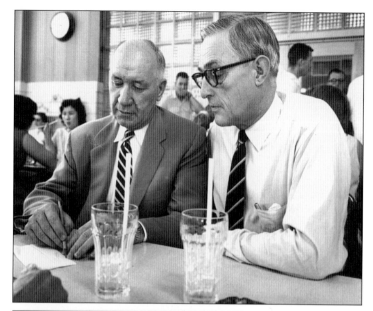

President Frasier and President Ross discuss the future of the institution over a drink at the Bru-Inn, the student union cafeteria. The two worked closely together to ensure a smooth transition from President Frasier's over-20-year administration of the college.

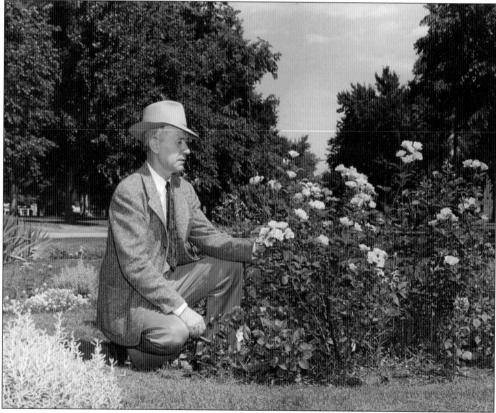

In 1948, President Frasier unexpectedly announced his retirement. His replacement was the vice president for buildings and grounds, Dr. William Ross. President Ross was an avid gardener, and during his tenure, he initiated many projects to improve the appearance of the campus.

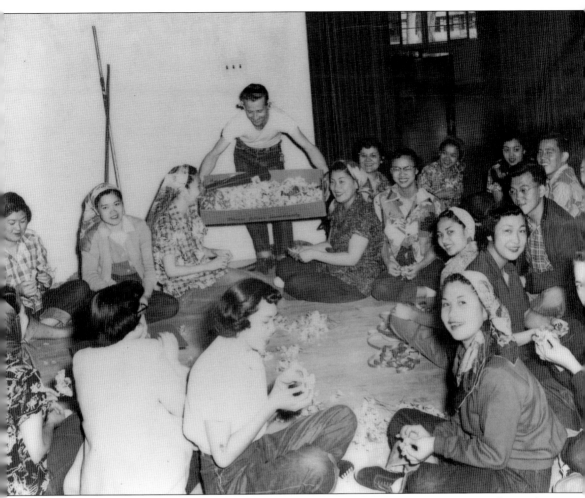

The college has always attracted a large number of Hawaiian students. In the 1940s and 1950s, the Hawaii natives formed a club called HUI KAMAAINA. These young women are making leis for the club's annual Lei Dance in 1947.

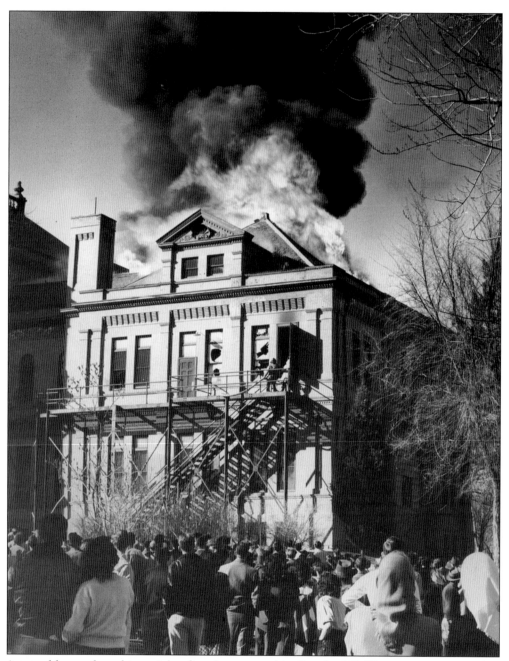

A crowd has gathered to watch a fire that erupted in Cranford Hall's east wing on Sunday, March 6, 1949. A week later another fire caused serious damage to the Bru-Inn, the popular cafeteria in the student union. Richard V. T. Clark, a disgruntled student, was arrested and charged with setting both fires. Clark was convicted and served six years in the Colorado State Penitentiary at Canon City.

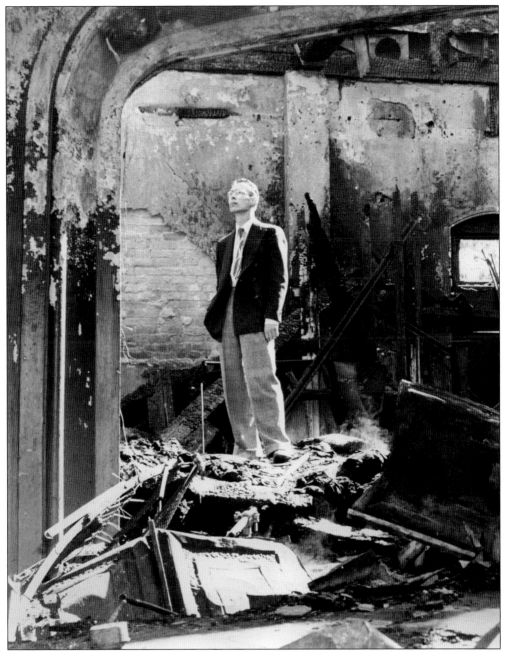

The 1949 fire that struck Cranford Hall completely destroyed the chapel that had served as the home for the Little Theatre of the Rockies (LTR) for over a decade. All of the LTR's sets, costumes, and other theatrical equipment were destroyed by the arsonist. In only four days, technical director Welby Wolfe and his staff were able to pull together and produce entirely new costumes and sets for a performance of The Male Animal at the Sterling Theater in downtown Greeley.

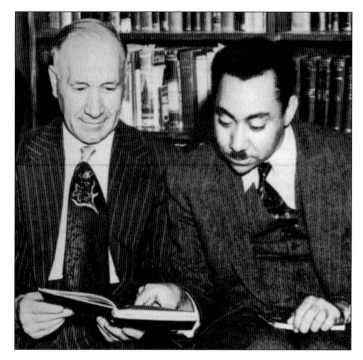

Sayyid Qutb was an Egyptian author and teacher whose work, Social Justice in Islam, is seen by many as highly influential with groups like al-Qaeda. Qutb received a scholarship to attend CSCE in 1948. While studying in Greeley, Qutb's critical views of the West were sharpened. He is seen here with President Ross.

Snyder Hall, named for President Snyder's wife, Maggie, along with Tobey-Kendel Hall and Sabin Hall were dedicated in 1936. These new halls served as women's dormitories from the college's growing population. President Frasier hoped that building these new dorms would increase student participation on campus.

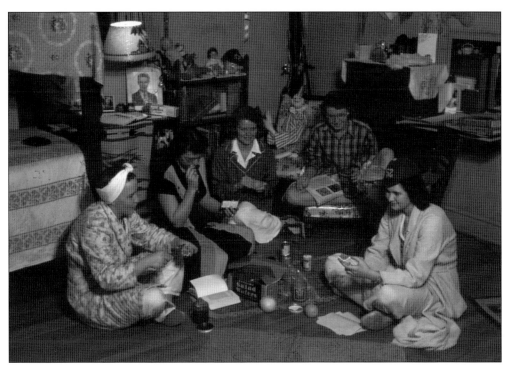

Residence halls were constructed between 1921 and 1947. These students gathered in one of the dormitories in 1949 were expected to follow fairly strict behavioral rules.

The Pride of the Rockies marching band evolved from the earlier Colorado State College of Education school band and gained prominence under the direction of music faculty member, Wayman Walker (1952–1976). Over the years, the organization became a fixture at football games, homecoming events, and regional parades.

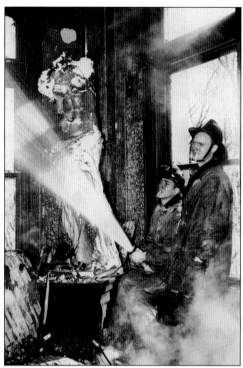

In 1951, a fire seriously damaged Guggenheim Hall. The fire was started by an overheating gas kiln in the pottery studio. Two Greeley firefighters, assisted by Venus De Milo, valiantly fight the blaze.

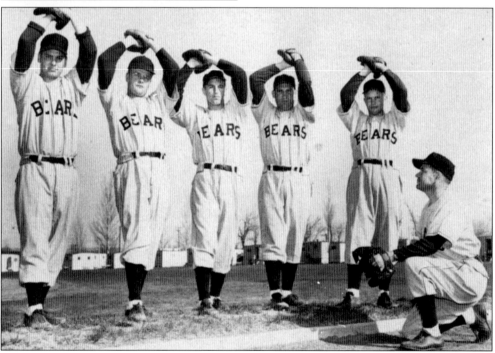

Baseball was a highly successful sport at the college. Pete Butler's baseball teams dominated the Rocky Mountain Athletics Conference winning the title 25 years in a row from 1945–1972. The team also went to playoffs of the College World Series 12 times. Coach Butler works with the pitchers of the 1952 team.

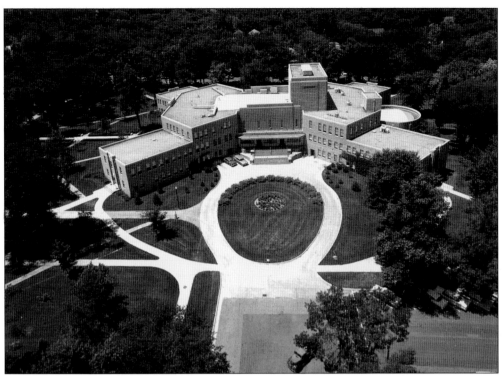

Construction began on Frasier Hall in 1951 after the fire caused extensive damage to Cranford Hall. When the building was completed, President Frasier attended the dedication of the building named in his honor on January 1, 1954. Frasier would serve as the new home for music, speech, and the Little Theatre of the Rockies among others.

Numerous events were held on campus for the faculty, the community, and the student body. A wide variety of dances included the Lei Dance, the Sophomore Ball, the Junior-Senior Prom, the Christmas Ball, and the Military Ball. As with many schools, a Sadie Hawkins Dance was also held on campus. The dance featured students in outrageous costumes and a reversal of traditional gender roles as seen in the 1962 dance.

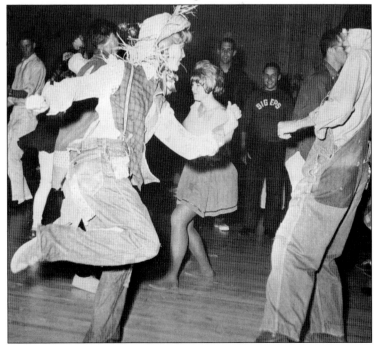

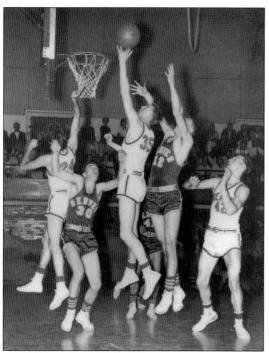

Basketball was one of the earliest sports on campus. The teams played in a wide variety of locations around campus ranging from the basement of Cranford Hall to the temporary gymnasium constructed during World War I. The completion of Gunter Hall of Health gave the men's basketball team a new home. The college did very well during its years in the Rocky Mountain Athletics Conference and the basketball team was conference champions in 1939, 1941, 1942–1943, 1946, 1948–1949, 1952 and 1965–1968.

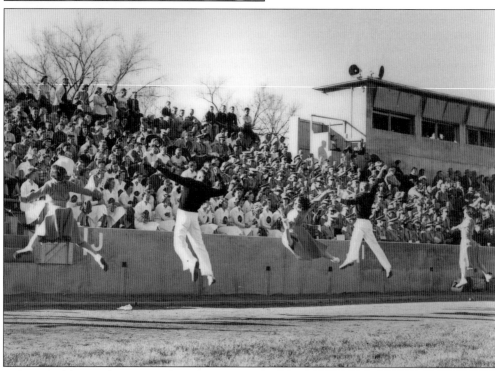

Jackson Field served as a home for many sporting events on campus. Renovations undertaken during 1948 were designed to increase the stability and safety of the stands. These renovations ended up reducing the seating capacity from over 5,000 to approximately 4,000 spectators.

The Garden Theater was completed on the central campus in 1940. It has served as a focal point for a wide variety of outdoor activities ranging from convocation to commencement. The class of 1958 is seen here seated during the spring graduation ceremony.

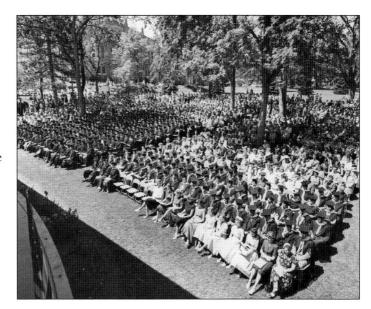

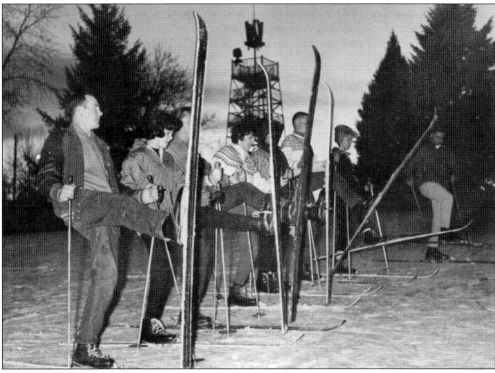

The postwar years saw the growth of honor societies, departmental clubs, and special interest clubs on campus. The new clubs included such diverse groups as the Jeans and Janes serving the square-dancing population and the Bjorn Ski Club for folks interested in winter sports.

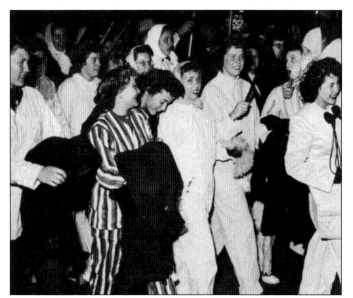

The annual tradition of homecoming included a parade that went through Greeley. The celebrations not only included the standard floats and band performances, but it also included the Nightshirt Parade or Pajama Parade. Students marched through the streets wearing their nightclothes and carried torches to light the celebratory bonfire.

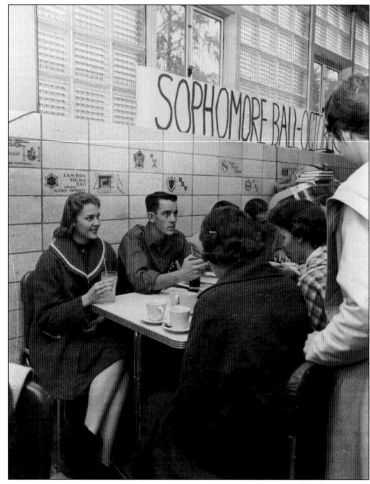

For many years the Bru-Inn, located in the Student Union, was a popular student dining and gathering spot. Its name was inspired by the college's mascot.

Four

COLORADO STATE
COLLEGE

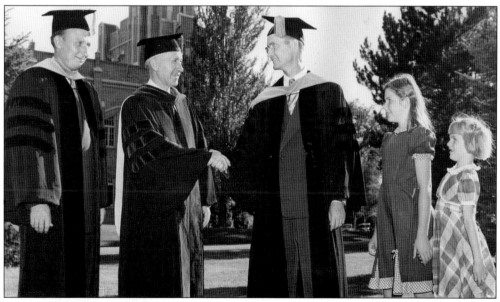

The graduate program began at CTC during the early 1910s. The institution awarded three students master's degrees in education in 1914. The first doctoral degree was awarded in 1934. The graduate school continued to expand as the campus's curriculum expanded. President Ross congratulates one of the doctoral students from the class of 1958.

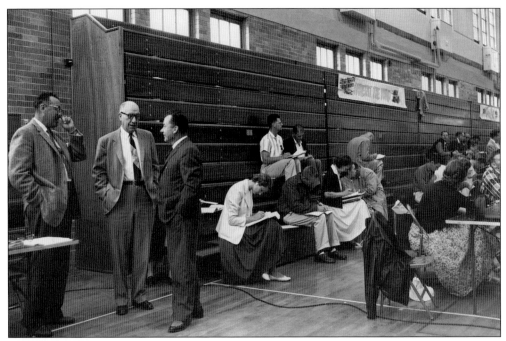

Registration day in Gunter, in the days before computers, was a time-consuming and often frustrating affair.

During the 1950s, students began demanding additional degrees beside the traditional teachers' education programs offered on campus. In mid-1950, the department of business was created in order to provide students the option of taking a business degree without requiring them to receive their teaching credentials.

Although the focus of CSCE continued to be on producing educators, additional degree programs began to appear on campus. In 1950, students could receive a bachelor of arts in the liberal arts, and by 1960, students could be awarded a bachelor of science degree.

Nursing classes had been periodically offered on campus, but the School of Nursing was not established until near the end of President Ross's tenure. It began as a minor in 1963, and by the next year, students could major in the field. The program grew significantly and continues to be one of the most prominent programs on campus.

Darrell Holmes succeeded Ross as president of CSCE in 1964. He was the first president of the institution who had never worked as either a teacher or administrator in the public school system. He led the institution through the transformation from college to university. President Holmes left UNC in 1971.

Dr. Oliver Dickerson and Daniel Seager examine some documents for Dickerson's research. Dickerson was one of the leading scholars under President Frasier. He was a member of the history faculty and served as head of the department. Seager was the head of the library for numerous years.

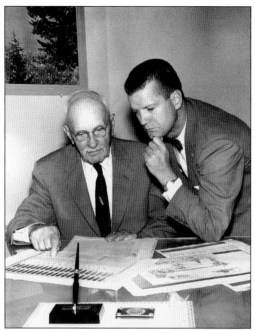

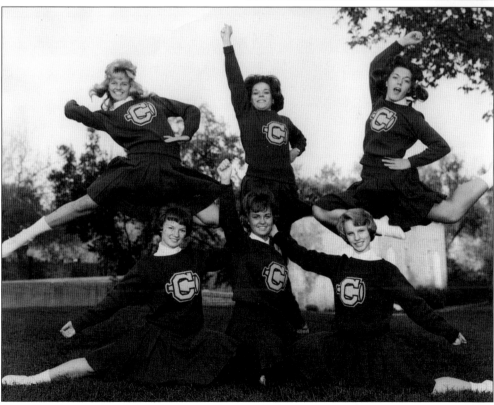

The all-male squads of cheerleaders and spirit leaders were supplanted by women during the early 1940s. The Student Activities Committee hand selected the women who became cheerleaders. They became standard fixtures at athletic events on campus.

The 1969 football team coached by Bob Blasi had a perfect season. The only defeat experienced by the team was in a traditional preseason scrimmage game with alumni. Despite the team's undefeated season, they were unable to participate in a national bowl game due to an esoteric ruling by the NCAA.

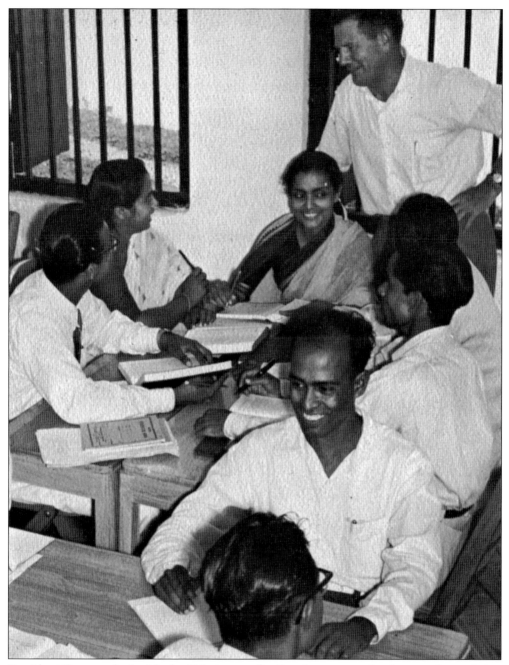

President Ross worked with the U.S. Agency for Development to begin a teacher-training project in East Pakistan (now Bangladesh). The Pakistan Project lasted for 10 years and resulted in the training of over 1,300 teachers in Bangladesh. Dr. Allan Elliott is seen here working with several students in capital of Dhaka.

The wrestling program was incredibly strong and won 36 Rocky Mountain Athletics Conference championships. Under the coaching of John Hancock Jr., the team won 30 titles in row from 1937 through 1966. All of this success led to large crowd turnouts for the wrestling meets, including this 1962 match.

Wellington Webb, who became the first African American mayor of Denver, earned both his bachelors and masters degrees from the Greeley institution. Webb played basketball for the Bears during his time on campus and can be seen here with the ball in this 1963 game against Idaho State.

In an effort to generate interest in studying science by students in secondary schools, the Frontiers of Science program was established at CSC in 1959. In the beginning, the summer program focused on reaching high school seniors, particularly students from rural areas. The program has now expanded and attempts to serve a wide variety of high school students.

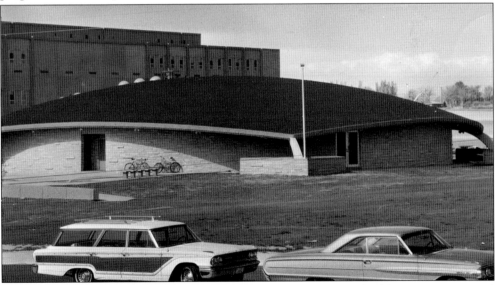

To accommodate the growing number of students in sciences, a new building was constructed in 1964 on the west campus. The Ross Hall lecture complex (foreground) and the Ross Hall of Science contained laboratories, offices, and classrooms. The building was renovated and expanded upon several times over the next several decades.

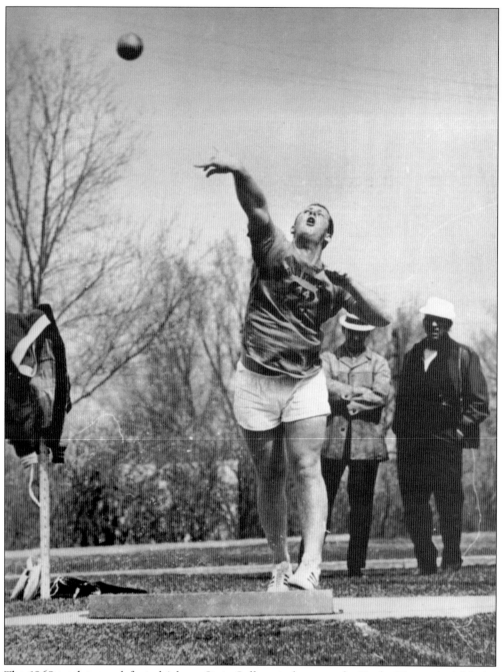

The 1968 track team defeated Adams State College to become the Rocky Mountain Athletics Conference champions. Angelo DiPaolo is throwing the shot put at one of the team's meets.

The growth of the student body necessitated a massive building project. President Ross acquired a 168-acre farm next to the campus to allow for the necessary expansion. The farm belonged to J. M. B. Petrikin, a prominent Greeley resident, and the site of his house became the location for the future University Center.

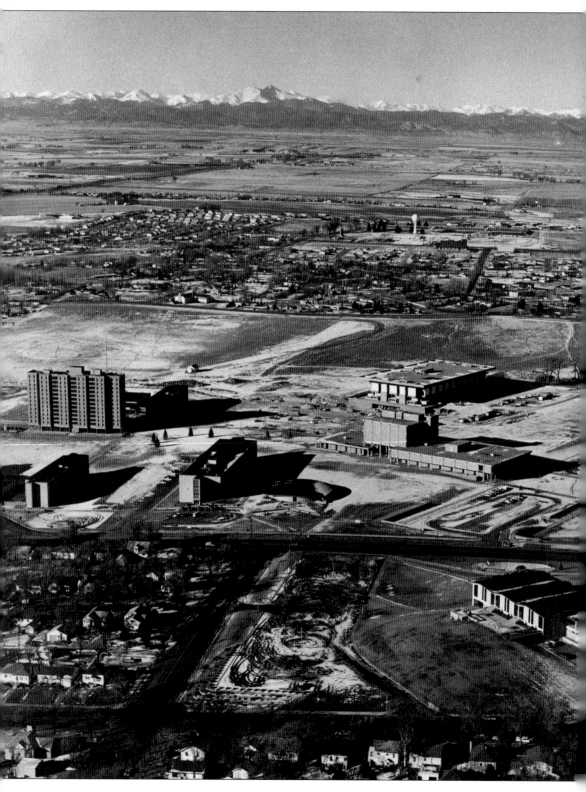

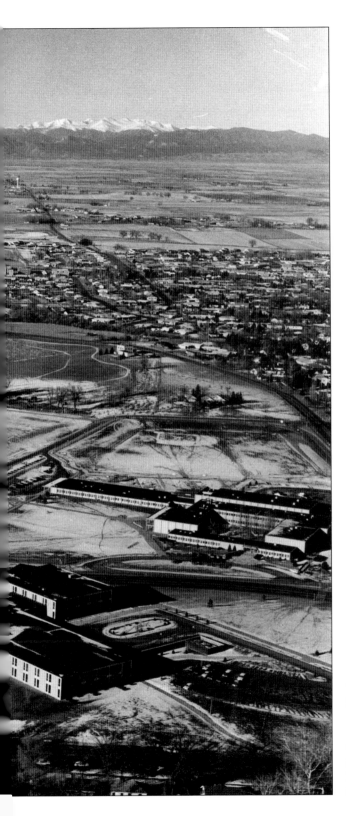

The college launched a massive building project beginning in the 1960s and continuing through the 1970s. A number of new buildings were constructed on the new west campus, including McKee Hall of Education, the University Library, and Candelaria Hall.

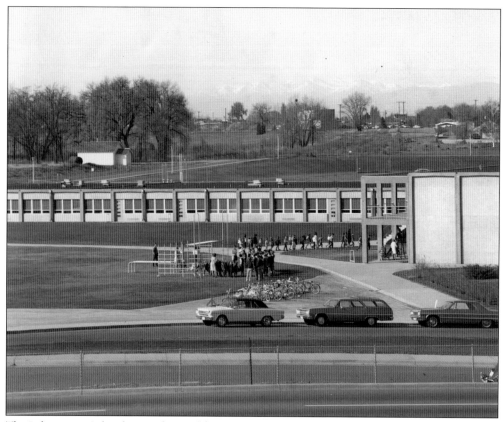

The Laboratory School was relocated from Kepner Hall to the newly constructed Bishop-Lehr Hall. Bishop-Lehr was completed in 1962.

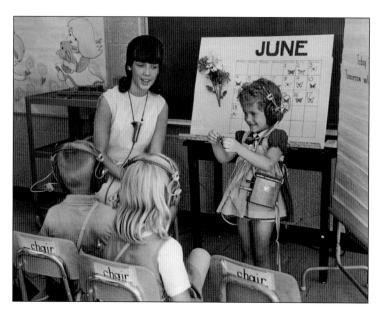

The Laboratory School contracted with Greeley School District 6 to operate its deaf and hard of hearing programs. Hearing-impaired students were included in regular classes, and teachers proficient in American Sign Language were hired to accompany teachers who had not learned ASL yet.

The Special Education program began in the mid-1950s as an option for specialization within the Education Department. UNC continues to provide valuable leadership in this field.

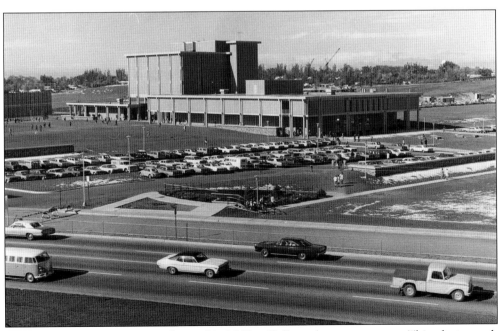

The College of Education was housed in McKee Hall on the west campus. This photograph was taken from the Panorama Room in University Center.

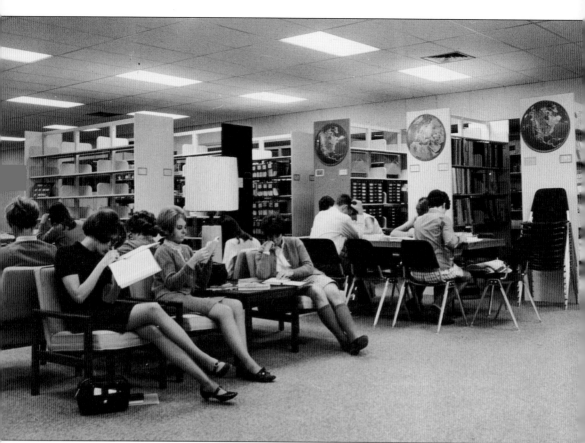

The McKee Hall of Education was intended to serve the needs of the growing campus community. It included a 500-seat lecture hall, psychological laboratories, an integrated audio-visual lab, and an educational resource library. The building was named for Dr. Paul McKee, a faculty member noted for his contributions to education and the creation of the McKee reading series.

McCowen Residence Hall was dedicated in fall 1963. This was the first year that residence halls were co-educational. The building was named for Dr. Annie McCowen. Professor McCowen came to the institution in 1921 and specialized in elementary arithmetic and reading. She was coauthor of two popular textbook series, including the Jack and Janet Reading for Meaning series.

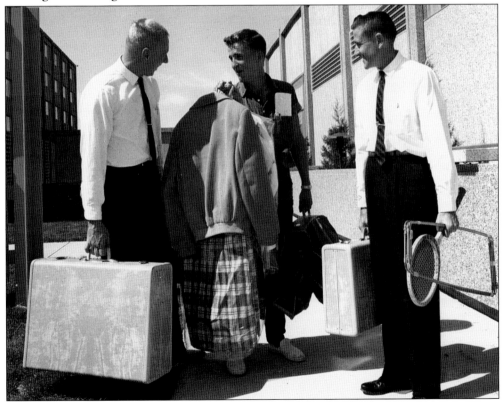

The photograph shows students moving into McCowen Residence Hall on west campus. McCowen was designed as a prototype for other residence halls on campus. It housed 500 students, and it was noted that each room contained a "new kind of bed, which will convert into a couch for daytime use."

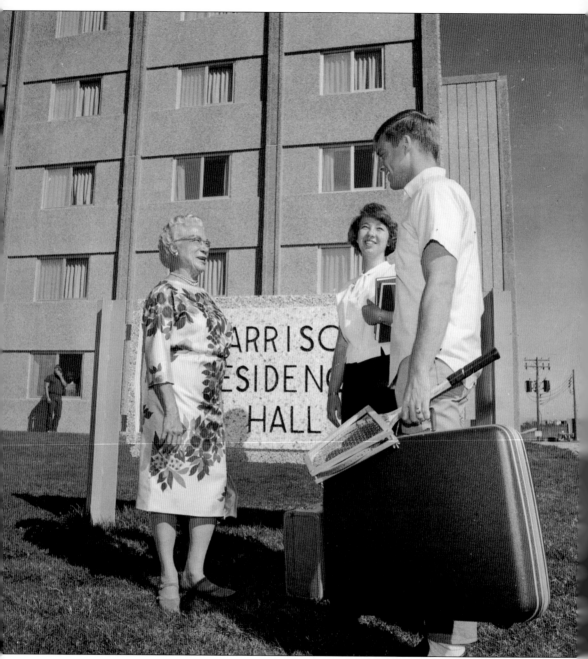

Lucille Harrison, a kindergarten teacher in the Laboratory School and author of a number of elementary English textbooks, greets students at the dedication of the residence hall named in her honor.

Connie Trimmer Willis graduated from CSC in 1967, where she had participated in numerous activities including serving as the president of the Associated Women Students. Willis went on to be a highly awarded science fiction author having won numerous Hugo and Nebulae Awards. She was also inducted into the Science Fiction Hall of Fame in 2009.

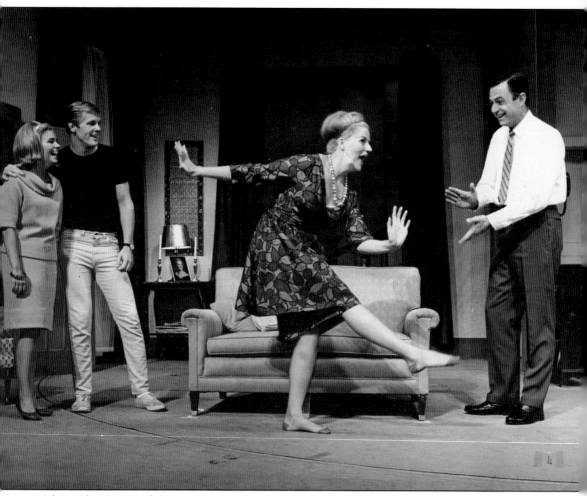

The Little Theatre of the Rockies developed a national reputation for excellence and attracted actors from around the region and the country to Greeley during the summer months. A young Nick Nolte (in the black shirt) participated in the theatre during the mid-1960s, including the 1964 production of *Come Back Little Sheba*.

The curriculum continued to expand throughout the 1960s. Several new majors became available for the first time, including Africana Studies, Hispanic Studies, and Women's Studies.

On the east campus, in the shadow of Cranford, it was still popular to hold class discussions outside on nice spring days.

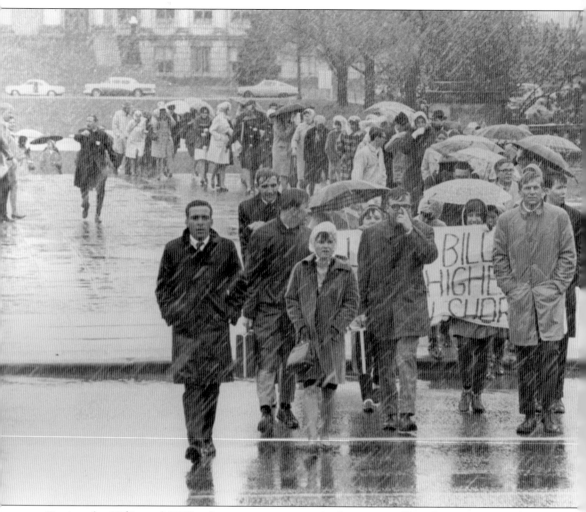

During the 1960s and 1970s, the campus community began to reflect the growing student activism that spread across the nation. In May 1967, during a terrible storm, a number of CSC students made the trip to the capitol building in Denver to protest potential cuts to the higher education budget proposed by the state legislature.

THE UNIVERSITY OF NORTHERN COLORADO

President Holmes diligently campaigned throughout the state so that the college would be granted university status. After two long years of lobbying, on April 14, 1970, a bill sponsored by Sen. William Garnsey of Greeley passed through the state legislature both granting the new status and changing the name of the institution to the University of Northern Colorado.

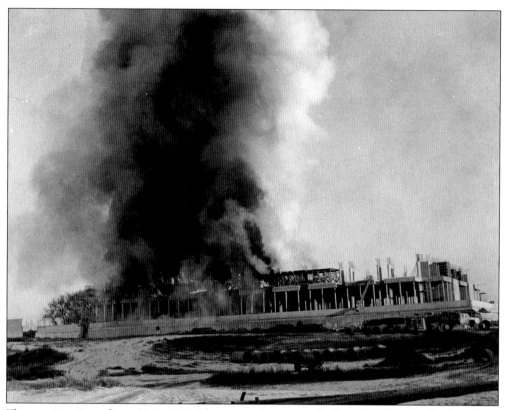

The construction of new University Library was interrupted when a serious fire broke out on the west campus construction site. The library cost almost $5 million to construct and took a great deal of President Holmes' political acumen to push through the legislature.

The construction of the University Library building was completed in 1971 during an era of considerable expansion on campus that coincided with the transformation of the college into a university. In 1973, the library was renamed in honor of alumnus and former faculty member, James A. Michener. During the dedication, Michener described a library as "a temporary resting place where the great idea of the world are kept in order."

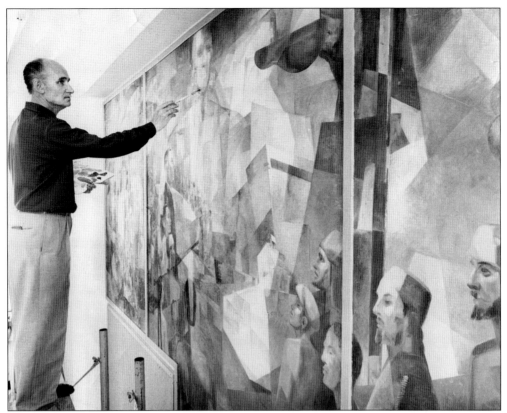

Walter Green, who had received both his bachelor's and master's degrees from CSCE, returned to teach fine arts at CSC from 1965 to 1970. His painting titled *Search for Knowledge* was created for his master's thesis. It originally hung in the Carter Library, but it was reinstalled in the James A. Michener Library in 1983.

Students gather outside Gunter Hall on registration day in the early years of the university.

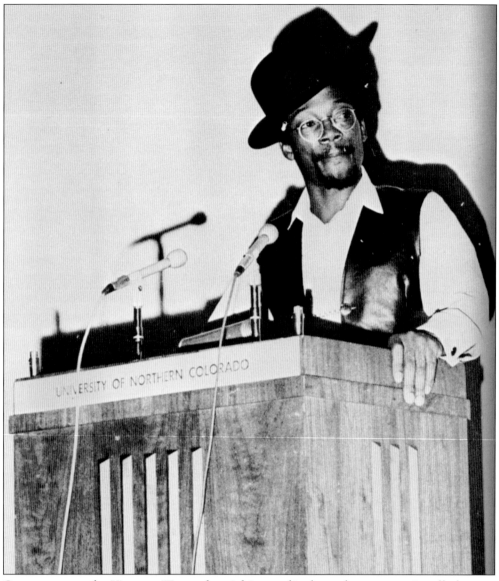

Concerns over the Vietnam War and racial inequality brought many nationally known speakers to campus. These alternative voices ranged from Jane Fonda to Corky Gonzales. Ray "Masai" Hewitt, the minister of education for the Black Panther Party, spoke at the "Faith in the People Event" on November 16, 1970.

Concerns for racial justice and equality led to the creation of numerous student organizations on campus. Several groups formed to meet the needs of minority students including the formation of the Race Relations Council and the Black Student Union. The United Mexican American Students strived to ensure that the voices of the Hispanic students were heard on campus.

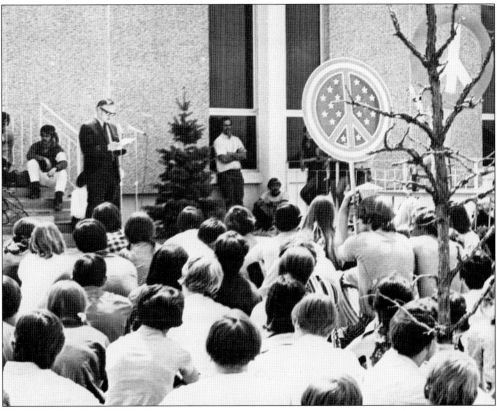

In response to the United State's invasion of Cambodia, many UNC students participated in a large demonstration on campus in May 1970. Students left their classrooms to gather and hear speakers discuss the volatile issue. Numerous other protests and demonstrations occurred throughout the month, including bomb threats and attempted arson on several university buildings.

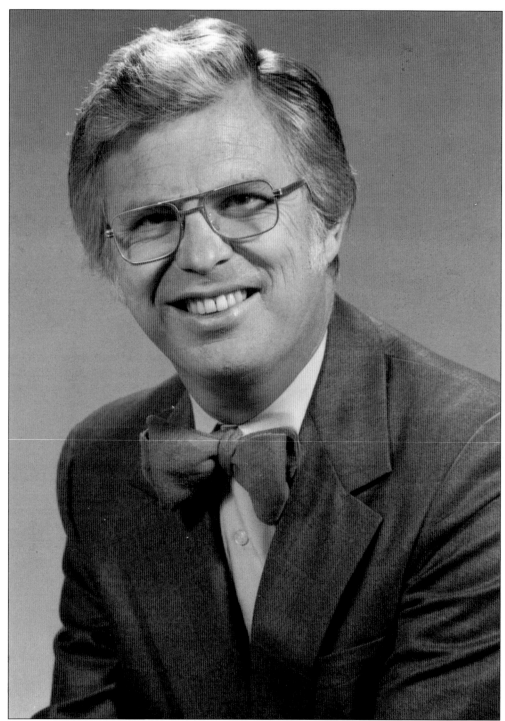

Dr. Richard Bond became the institution's president in 1971. He was the vice president for academic affairs at Illinois State University in Normal, Illinois. He worked hard to develop foreign exchange programs at the university and helped develop the institution's international reputation. He served as UNC's president until 1981.

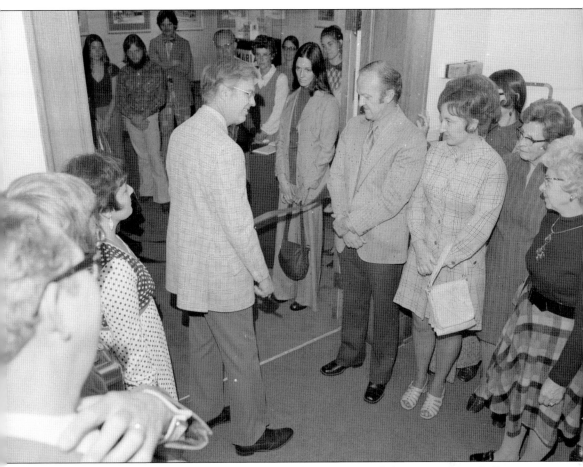

President Bond is about to cut the ribbon on the opening of the Mariani Art Gallery in Guggenheim Hall on October 14, 1973. The gallery is named for John I. Mariani, a faculty member and chairman of the fine arts department hired by President Frasier. The Mariani Gallery continues to host a wide variety of art instillations.

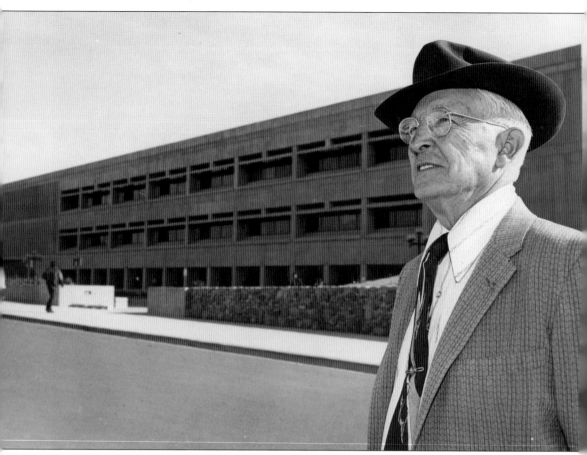

Martin Candelaria poses outside the building on west campus that was named after him. Professor Candelaria came to the college in 1948, taught Spanish and Hispanic studies for over 30 years, and was instrumental in developing the Language Arts Center.

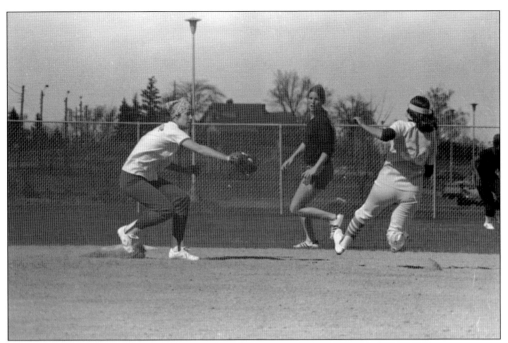

The women's softball team began in the late 1960s. The team was very successful and made 13 straight appearances at the Women's College World Series. Unfortunately in 1984, UNC's administration determined that 7 out of the 19 intercollegiate sports needed to be cut for a variety of reasons. The softball team was a victim of this decision but was restored to campus in 1999.

As the sports programs outgrew Gunter Hall, a new facility was needed to provide them the necessary space. The Butler-Hancock Sports Pavilion was constructed in 1963 and was named to honor two of the Bears' long-standing coaches, John Hancock Jr. and Pete Butler.

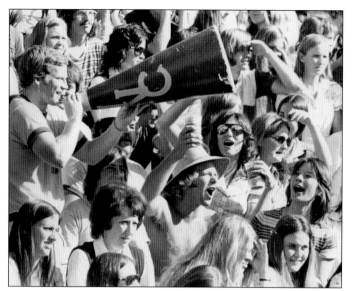

For much of the institution's history, the school colors were purple and gold. Even the alma mater included the line regarding the "friends of Purple and Gold." However in the mid-1960s, the athletic program began using navy blue and gold. This sparked a controversy that lasted until 1976 when President Bond declared the academic colors to be purple and gold, while the athletic colors will be blue and gold.

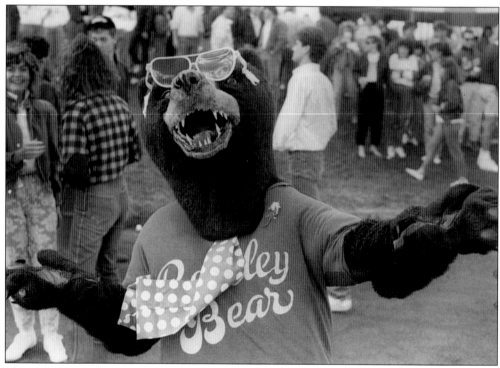

The State Teachers College athletic teams were simply known as the Teachers for many years, until in 1925, when the school adapted the bear as its mascot. In 1926, a live bear cub was given to the school. "Warden" the bear participated in parades and made appearances at games. However he repeatedly escaped, causing both panic and damage in the community. Due to these activities, Warden was eventually returned to Denver and replaced by a less dangerous substitute.

Bob Blasi joined the football coaching staff in 1956 as an offensive line coach. He became the head coach in 1966 and began to transform the program. He would lead the team to 107 victories, five conference titles in the Rocky Mountain Conference and the Great Plains Athletics Conference, and one NCC championship. In 1984, Blasi retired after 19 years as head coach.

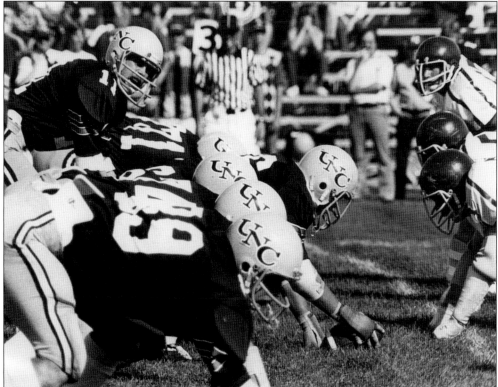

The university joined the Division II North Central Conference in 1979; wherein the football team went on to win the NCC championship during their first season in 1980. UNC went onto the division II national playoffs, where they lost to Eastern Illinois University. During the 2002–2003 season, the athletics department began the process of reclassifying as a division I school.

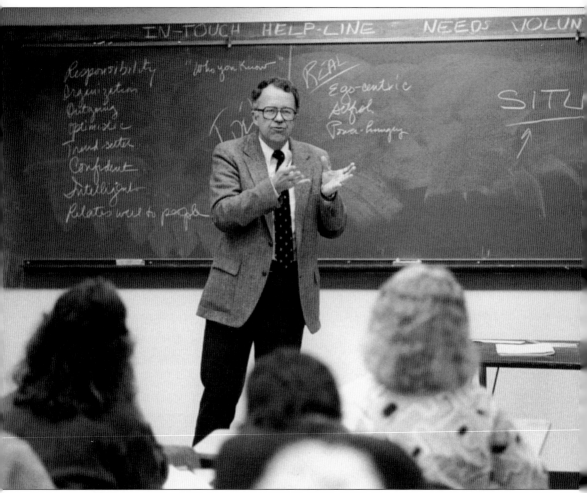

Pres. Robert C. Dickeson was serving as head of the Arizona State Department of Administration when he was recruited to be the university's eighth president. As president, he introduced a management by objective approach to academic planning.

Intercollegiate sports for women began to truly develop at UNC during the 1960s. At this time, the women's physical education department sponsored several sports including tennis, volleyball, field hockey, badminton, fencing, and softball. With the equality enforced by Title IX, the UNC volleyball team grew in prominence and won several Continental Divide Conference championships.

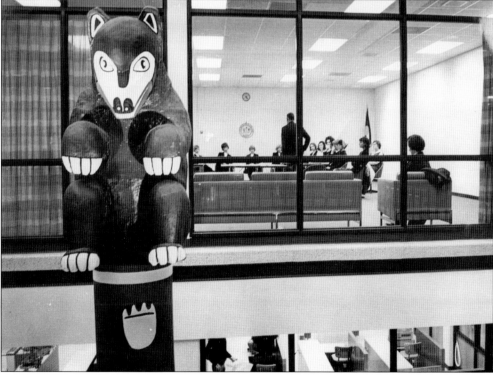

For his first 50 years on campus, Totem Teddy's life was a hard one. He was kept outside where he was attacked by woodpeckers and termites. He was kidnapped by students from rival schools, tarred, feathered, and set on fire. In the mid-1940s, the wooden bear was replaced by a concrete one. Finally late in his tenure on campus, he was fully restored, repainted, and placed in an atrium in the University Center where he remained until he was finally repatriated to the Klingit people in 2003.

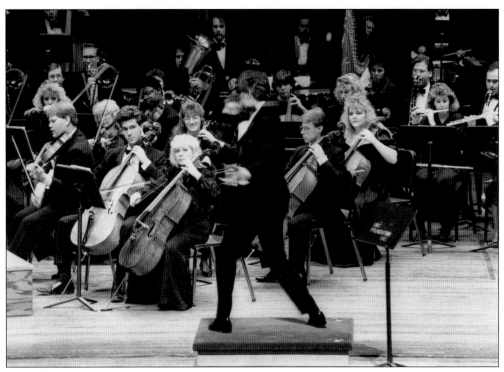

The Greeley Philharmonic Orchestra, a collaboration between the city of Greeley and the University of Northern Colorado, is Colorado's oldest orchestra in continuous existence. Howard Skinner is shown here conducting in the Union Colony Civic Center.

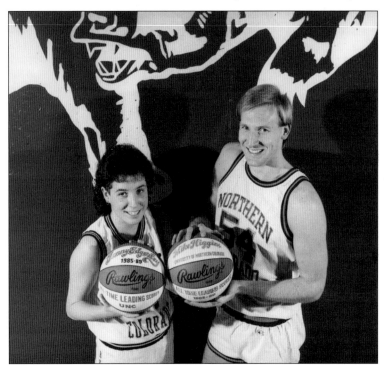

The Bears men's basketball team won the North Central Conference championship in 1989. The 1989 season also saw two exceptional players from both the men's and women's teams. Jenny Edgerley and Mike Higgins became the all-time leading scorers at the university.

The University of Northern Colorado celebrated its 100th anniversary in 1989. During this monumental year, President Dickeson signed a cooperative agreement with two educational institutions in Taiwan.

By 1971, Cranford Hall had been closed for several years, as a safety hazard. President Bond commissioned several studies in an attempt to find a way to save it, but all concluded it was structurally unsound. In summer 1971, it was demolished.

This picture shows, from left to right, President Ross, Dave Reichert (director of the Physical Plant), and President Bond opening the time capsule that was hidden in the cornerstone of Cranford. The handbill being held advertised a special railroad fare of $1 for a round-trip ticket from Denver to Greeley on June 13, 1891, for those wishing to attend the cornerstone-laying ceremony of the new Normal School building.

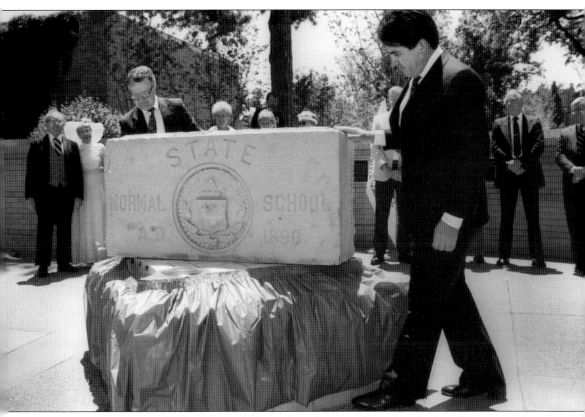

On June 13, 1990, Cranford Park was dedicated on the site where Cranford Hall once stood.

www.arcadiapublishing.com

Discover books about the town where you grew up, the cities where your friends and families live, the town where your parents met, or even that retirement spot you've been dreaming about. Our Web site provides history lovers with exclusive deals, advanced notification about new titles, e-mail alerts of author events, and much more.

MADE IN THE USA

Arcadia Publishing, the leading local history publisher in the United States, is committed to making history accessible and meaningful through publishing books that celebrate and preserve the heritage of America's people and places. Consistent with our mission to preserve history on a local level, this book was printed in South Carolina on American-made paper and manufactured entirely in the United States.

This book carries the accredited Forest Stewardship Council (FSC) label and is printed on 100 percent FSC-certified paper. Products carrying the FSC label are independently certified to assure consumers that they come from forests that are managed to meet the social, economic, and ecological needs of present and future generations.

FSC
Mixed Sources
Product group from well-managed forests and other controlled sources

Cert no. SW-COC-001530
www.fsc.org
© 1996 Forest Stewardship Council

Find Your Place in History.